SECRET LEEK

Neil Collingwood

This book is dedicated to Sue Fox who stands by me no matter what, for which I will always be truly grateful.

First published 2016

Amberley Publishing
The Hill, Stroud
Gloucestershire, GL5 4EP

www.amberley-books.com

Copyright © Neil Collingwood, 2016

All the illustrations are the authors', except where acknowledged.

The right of Neil Collingwood to be identified as the Author of this work has been asserted in accordance with the Copyrights, Designs and Patents Act 1988.

ISBN 978 1 4456 6372 2 (print)
ISBN 978 1 4456 6373 9 (ebook)

All rights reserved. No part of this book may be reprinted or reproduced or utilised in any form or by any electronic, mechanical or other means, now known or hereafter invented, including photocopying and recording, or in any information storage or retrieval system, without the permission in writing from the Publishers.

British Library Cataloguing in Publication Data.
A catalogue record for this book is available from the British Library.

Origination by Amberley Publishing.
Printed in Great Britain.

Contents

	Introduction	4
1	Leek on the Drawing Board	6
2	Leek Under the Ground	18
3	Leek Through the Lens	28
4	Leek Through the Window	37
5	Leek Through the Post	46
6	Leek Behind Bars	55
7	Leek Through the Smoke	64
8	Leek on the Way to Hospital	76
9	Leek Down the Barrel	85
	About the Author	96
	Acknowledgements	96

Introduction

The small, market town of Leek is popular with visitors who enjoy the comparatively slow pace of life, the attractive architecture and the easily accessible countryside. Leek has not always been this quiet though, having been a bustling textile town employing thousands of people in its mills.

Some of the earliest evidence about Leek's history comes from the 'Nine Pins' located on a hill overlooking the thirteenth-century Dieulacres Abbey. Whether the Nine Pins were trees or stones is unclear today and theories suggest that the hill was the site of a prehistoric fort or a stone circle. Although no detailed archaeological work has been found, in the early 2000s a worked flint was located there, confirming some form of prehistoric activity. Another source states that it was the site of a burial mound, from which two cist burials were robbed in the 1800s. A burial mound, named 'Cock Low' certainly existed near the present Spring Gardens but was swept away by house-building in 1907. The mound contained Middle Bronze Age remains and artefacts, proving that an area quite close to the town centre was occupied between 2500 and 800 BC. Moving forwards, there is evidence of Roman camps and roads fairly close to the town, although no Roman structures are extant. 'Lek' was certainly in existence between the time of the Norman invasion by Guillaume le Conquérant (better known in the Anglicised form as William the Conqueror) and the completion of his Great Survey in 1086. The Domesday Book stated: 'The King holds Leek, Earl Algar held it' – Algar being an important Saxon ruler before the invasion. Parts of Saxon preaching crosses in St Edward's churchyard witness that Christian converts were worshipping close by in the tenth century. It seems likely that the town developed around this hill from where the unusual 'double sunset' could be observed and also where a spring emerged, making it an important site for pagans who performed sacrifices to ensure a continuing supply of water for their settlement. These factors may have determined why the first parish church was erected there and why subsequent churches were built on the same site. It may also explain the name 'Leek', believed to derive from Old English or Old Norse words, both meaning 'brook'. The brook in question seems likely to have been the one running down Spout Street (now St Edward Street) from the spring or 'spout' mentioned above.

Leek's biggest secret seems to be why the town became such a major force in the silk industry; if you ask local historians why this was, they will skirt around the River Churnet, the Huguenots and Macclesfield before finally admitting that no-one really knows. Leek is not all that far from Macclesfield, another major silk town, but the same question asked there would almost certainly produce the same response. Perhaps an entrepreneur saw beautiful silk buttons arriving from Italy and seized the opportunity to make money by producing and selling his own. It is easier to put forward a reason why Leek became so prominent in silk dyeing, it having been stated many times that the plentiful supply of

perfect water from the River Churnet was crucial – but in order to perfect silk-dyeing you had to have the silk to dye in the first place. That Leek was important for silk is undeniable and although many mills have been demolished, plenty of reminders of these once great industries still stand and are finding new uses. The importance of Leek for silk is emphasised by the many visits paid by William Morris to the Wardles in St Edward Street while he learned how to dye Indian tussar silk, which was later woven into exquisite Arts and Crafts fabrics. Although the silk industry will not be discussed in detail in this volume – having been done well elsewhere – it is fair to say that the wealth generated by silk made the men who play major roles in virtually all of the chapters of this book. It is no accident that the same small group of men recur continually throughout, but there are many other such groups who could be shown to have been just as prominent. It is hoped that this book will reveal many new facts and help to unlock some of Leek's secrets.

1. Leek on the Drawing Board

People enjoy visiting towns and villages with interesting architecture and if you speak to visitors to Leek they will often tell you that they enjoy the great variety and quality of the buildings they can see in the town. Leek's architecture covers a wide range of periods and architectural styles and is loved by tourists and residents alike, but who was responsible for designing Leek's eye-catching buildings? In Nikolaus Pevsner's *The Buildings of England: Staffordshire*, he stated that:

> The time of the greatest prosperity was in the C19. In architecture Leek presents the interesting case of one Architect and his son almost monopolising public and private buildings for the last third of the C19 and into the C20. They are William Sugden and his son William Larner Sugden.

It is difficult to look at any photograph of Leek without being drawn into mentioning the Sugdens, but they were not the only architects at work in the town and it seems long overdue that some of their competitors become more than just names on a list. This section looks at some of these other architects and their most notable buildings.

Although the word architect was first used in seventeenth-century England, in Leek it does not seem to have been used commonly until the mid-nineteenth century. William Sugden referred to himself as an architect as early as 1851 but others referred to themselves simply as surveyors.

The designers of early buildings are often unknown and were usually skilled joiners (in the case of timber-framed buildings), builders or masons, not formally qualified in building design. As is probably the case with many small towns, when a prestigious building was required, outside architects were generally brought in, hence All Saints' Church (Leek's only Grade I-listed building) and Spout Hall were designed by London architect (Richard) Norman Shaw and the Nicholson War Memorial by Thomas Worthington & Sons of Manchester. St Luke's Church and St Mary's Catholic Church were also the work of outsiders. The railway stations on the Churnet Valley line, including Leek Station, are also attributed to outside architects and, perhaps controversially, Robert Jones, an architect from Newcastle-under-Lyme, attributes them to Andrews & Pepper of Bradford, stating that William Sugden, who is normally credited with their design, was only the architects managing clerk and came to Staffordshire simply to oversee their building, an assertion quite likely to provoke strong opinions.

Thomas Brealey

A family that represents even more of a dynasty of Leek architects than the Sugdens, is the Brealeys. Thomas Brealey moved to Leek from Derbyshire by 1832 and had three

sons: John, William Woodhouse and Thomas. Although Thomas Snr was primarily a land agent (the occupation often attributed to architects at the time), he was listed in an 1834 directory as an attorney's clerk. Not many buildings have been attributed to Thomas himself but a plan from 13 March 1886 is recorded for Thomas Brealey to build five houses at the end of Westwood Grove. He is most important though for founding the firm, which continued after his death as Thomas Brealey & Sons, with John Brealey (below) as senior partner.

John Brealey was born in Leek in 1834 and by 1861 was living with his parents in Stockwell Street, already working as a land surveyor. In 1869, he married Harriett Woolley in Leek. A J. Brealey, presumably John, is mentioned in Pevsner's *Staffordshire*, where Pevsner stated that when G. E. Street's 'dramatic restoration' of the chancel at St Edward's Church took place in 1865–67, the plans were signed by J. Brealey. Brealey, says Pevsner, 'must have worked to Street's design'. Although this sounds like a fairly modest task it would have represented quite a feather in John Brealey's cap as Street was one of the leading Gothic Revival architects, responsible for work on scores of churches and probably most famous for building the spectacular Royal Courts of Justice. Street was so highly thought of that on his death he was interred in Westminster Abbey. By 1871 John Brealey was living at No. 42 Stockwell Street, a large attractive semi-detached house. He employed one servant and was listed as a surveyor and landowner. Indeed that year Brealey wrote a letter to a local newspaper on the subject of the French Peasant Farmers Relief Fund and signed himself a 'member of the Royal Agricultural Society of England'. Four years later on 12 April 1875, Brealey was one of ten directors of the Union Buildings Company. Union Buildings were built in Market Street as a private club and concert venue, which followed the principles of the temperance (teetotal) movement. No longer a popular cause in the Leek of that time, the company failed after just four years. Union Buildings were subsequently bought by Leek's Improvement Commissioners who had it converted into the new town hall.

By 1881 John Brealey and his family had moved to No. 36 Derby Street, a large house now occupied by Ryman's and Staffordshire Wildlife Trust. He employed two live-in servants despite him and his wife having no family. John Brealey seems to have been mainly a domestic architect and is credited with having designed houses in Bath Street, Queen Street, Portland Street, Grosvenor Street and Moorhouse Street. The most notable work done by him though are the alterations to the Cattle Market Inn, which include terracotta decoration to the front, including the date '1875'. Between 1890 and 1894, John Brealey was chairman of the Leek Improvement Commissioners, the forerunner of Leek Urban District Council, which he also later chaired. As a surveyor and architect he would have been a useful man in both roles. His position in the council was not without controversy though (*see* John Thomas Brealey below). In September 1901, John Brealey of No. 36 Derby Street died aged sixty-seven. He was buried in Leek Cemetery, described as a land agent and surveyor. His estate was valued at £24,916 15s 7d, a very substantial sum at that time.

John Thomas Brealey, No. 15 Stockwell Street and Piccadilly, Hanley

John Thomas is the best known of the three generations of Brealey architects who worked in Leek, although his relationship with the others has sometimes been confused. He

has often been stated to be John Brealey's son, but he wasn't. He was actually the son of John's brother William Woodhouse. William Woodhouse Brealey was born in Leek but moved away to Stoke-on-Trent working in several jobs, including being an engineering draughtsman, and never worked in his father's business.

In some regards, John Thomas perhaps should not be thought of as a Leek architect, given that he had been born in Stoke-on-Trent in October 1859 and still lived in Fenton with his father in 1891. In 1892, John Thomas married and moved to Horton with his new wife where he was described as an 'Architect Surveyor'. He was then taken into business by his uncles (John and Thomas) and perhaps felt that he was likely to succeed to the business because John had no children and Thomas's son Reginald wasn't born until John Thomas was already twenty-three. John Thomas began to practise from No. 1 Stockwell Street and by 1911 was living at The Knoll in Rudyard, a ten-roomed house that had been built in 1894–95, probably to the design of Brealey himself. The first job John seems to have done in Leek was to design five houses in Daintry Street in 1889. These houses, still standing, consist of two pairs of semi-detached properties and beyond them a very large detached house. It seems that his uncles did not see John T. as the natural successor to the family business as Reginald Woodhouse Brealey, Thomas' son, had also undertaken surveyor training making him the obvious candidate. Rather than making John Thomas the beneficiary of his will, John Brealey chose his wife's nephew J. W. Woolley, which probably explains why when John Thomas died he was working for Brealey, Parker and Woolley of Stockwell Street, Leek.

The buildings for which John Thomas is best known include the Stockwell Street offices for the Leek & Moorlands Building Society (1894–95), now occupied by Leek Town Council. He designed the infirmary block at the Union Workhouse on Ashbourne Road in 1898, for which he apparently received some criticism but excused this on the basis that the site had been difficult to work on. He also designed the 1898 fire station in Stockwell Street, (now 'The Engine Room') and his most notable, albeit extremely controversial, piece of work was the Butter Market (1897).

The last two buildings mentioned were part of a proposed grand redevelopment of the town centre, a pamphlet about which was issued to every household in the town. Its title was 'Proposed Butter Market and Fire Station etc.', a proposal that proved as controversial as every large-scale modern development today. The improvement commissioners had been replaced in 1895 by the urban district council with twenty-four councillors, fifteen of them former commissioners. This group now administered public works such as water supply, street-cleansing, the fire brigade and markets. Among the councillors were two architects/surveyors: John Brealey, who was the chairman, and J. C. Critchlow.

When it was proposed that a new indoor market be built, the decision was taken to select the winning design by means of a competition with a prize of £50. The competition entries, in some or all cases entered under pseudonyms, were first discussed by the councillors on 18 April 1895, having been available for inspection since 6 April. Three councillors raised objections to the way that the competition was being run, feeling that an external, independent architect should make the final decision but this motion was defeated on the basis that the decision had already been made, the winner being 'Halfpenny Stamp'. Second place was awarded to 'Bon Marche'. Three councillors again

Right: The Knoll, Rudyard, the home of John Thomas Brealey (1895).

Below: The old headquarters of the Leek & Moorland Building Society (1895).

Above: Fire station in Stockwell Street (1898) designed by J. T. Brealey.

Left: The Butter Market (1897) by J. T. Brealey.

objected but were overridden by Thomas Shaw, chairman of the Markets & Estates Committee, who would not countenance an outsider having the final say. Bon Marche then objected on the same point but their objection too was dismissed. There was much debate about the issue but eventually Mr Shaw's decision was ratified by the rest of the council and the envelope from 'Halfpenny Stamp' was opened to reveal the winner's name. Halfpenny Stamp turned out to be John Thomas Brealey, nephew of the council's chairman, who worked for him in the family firm (as well as from his own office in Hanley). John Brealey stated that he was unaware that his nephew had entered the competition and whatever discussions took place after this revelation and however much a conflict of interest this seems, J. T. Brealey's designs were used for the Butter Market and soon afterwards also the fire station in Stockwell Street. The covered market, which was intended to occupy the present Silk Street car park, was never built.

J. T. Brealey played an active role in the community of Rudyard, where he lived, and after 1904 was actively engaged in trying to prevent the North Staffordshire Railway (NSR) from fully developing Rudyard Lake as a visitor attraction, on the grounds that it would disrupt the lives of the wealthy entrepreneurs who were having houses built for them in the area. Regardless of these objections, Brealey was the honourary secretary of Rudyard Lake Gold Club between 1906 and his death in 1911, despite the club being owned by the NSR. John Thomas was keen on shooting and, like many architects, was also an artist.

DID YOU KNOW?
Half-timbered buildings like the Roebuck and the Green Dragon would have had their frames cut to size and joined together in a joiners yard, a process known as 'framing'. The frame would then have been dismantled and transported to the building site on ox-carts.

Unfortunately, as well as his successful, albeit controversial, work on the Butter Market and fire station, J. T. Brealey was also responsible for what may have been the area's greatest architectural blunder ever. He designed the beautiful St Gabriel's Church at Rudyard, close to where he was living, in the Italianate style, which was opened in 1905 at the top of Whorrock's Bank (now Camrose Hill) opposite the quarry from which its building stone was extracted. Unfortunately the site, donated by Hugh Sleigh of Leek, was basically a quarry spoil tip at the top of the extremely steep hill, descending to Lake Road. Even without the benefit of hindsight, it seems incredible that Brealey would have placed the church here and with a heavy campanile (bell tower) on the east side, furthest from the road. Although an architect's principal job may be to design buildings, this surely cannot be done independently of surveying the building site and Brealey always described himself as an 'Architect Surveyor'. His surveying skills certainly failed him here as by 1917, only five years after it opened, St Gabriel's was showing signs of subsidence and in 1928 had to close for services, having shown a strong inclination to relocate itself to Lake

St Gabriel's Church in Rudyard (1905) by J. T. Brealey. This has now been demolished.

Road. The church then stood unused until its demolition around 1946. John T. Brealey died in 1911 aged fifty-one. His effects were worth £13,996 3s 9d, £11,000 less than his uncle John had left in 1901. He was buried in Horton churchyard, where he was joined later by his widow.

It was reported in the *Leek Times* on 5 August 1911 that Mr Reg. T. Longden, architect of Leek and Burslem had acquired the business connection of the late Mr J. T. Brealey of Brealey, Parker and Woolley of Stockwell Street, Leek. In Kelly's Directory of Staffordshire (1940), Thos Brealey & Son Land Agents was listed in Derby Street; if this was Thomas Jnr's business, it appears that there may have been four generations of Brealeys in Leek who were land agents/surveyors/architects.

Reginald Thelwall Longden

Reginald Longden was born in Burslem in 1880, the son of a builder. At the age of twenty-one, Reginald, living with his parents in Burslem, was already described as an architect and surveyor. By 1911 Longden was living in Spencer Avenue, Leek, and had been married for seven years. He was already wealthy enough to employ two live-in servants, including a nursery governess. Longden was responsible for designing several striking Leek buildings, including the Co-operative Emporium in High Street in 1910. In 1912 he designed an attractive gentleman's residence on Park Road, for John Hall of Ball Haye Hall. This house, Bettyswood, was very grand both inside and out but was divided into two – Bettyswood and Gunside – quite soon after it was built. It is now Grade II listed but sadly for would-be viewers it is entirely obscured from the road by vegetation.

The gardens, which forty years ago were beautifully maintained, are now overgrown and untended although the same person now owns both halves, which may eventually

Co-op Emporium, High Street (1910) by Reginald Thelwall Longden.

Bettyswood, soon after completion by R. T. Longden.

The drawing room, Bettyswood (1912) by R. T. Longden.

Bettyswood, Park Road in 2016.

be re-amalgamated and perhaps the gardens will then be restored. In 1916, Longden was working from No. 66 St Edward Street, one half of Spout Hall. By 1921 he lived in Finney Street and worked from No. 43 St Edward Street, opposite the present Leek United Building Society. Longden designed the striking classical office block for Wardle & Davenports that stood next to the mill in Belle Vue, which, although only built in 1926–27, was demolished in the 1970s. In the 1920s, partnership Longden & Venables were described as architects of Leek and Burslem and designed the Nab Hill Avenue and Hillswood Avenue estate (9 acres) in 1924–27. Longden of Wolstanton died in 1941.

DID YOU KNOW?
Prestigious Victorian architect Norman Shaw designed two buildings in Leek: Spout Hall in St Edward's Street (1873) and All Saints' Church on Compton (1885). All Saints is Leek's only Grade I-listed building.

Uriah Hudson
Uriah Hudson's professional life followed a rather different path from other Leek architects in that he appears to have followed two professional paths simultaneously. He is said to have been educated in Leek by surveyor John Jones and is attributed with

having designed a house in West Street as early as 1857. Despite this, in the 1861 census he was living in South Street, listed as an attorney's general clerk.

Over the following ten years he is credited with designing more than twenty buildings, including Cawdry House (not the original building of that name but the solitary house standing in the gated lane next to St Luke's Church) and the Cattle Market Inn, both in 1867. By 1871 Hudson was described as a land agent and surveyor in Russell Street but was only attributed with two domestic buildings in that year and none later, although he was involved in the Market Street town hall building in the 1870s and 1880s. In 1881 he was again described as a solicitor's general clerk and by 1891 as a retired land surveyor. It seems possible that his skills in surveying and architecture were called upon in his work for solicitors' offices, perhaps because lawyers were often parties to legal agreements concerning the sale of land and properties so his skill set allowed him to determine that these agreements were fair and equitable.

James Gosling Smith

James Gosling Smith was born in Leek in 1845 and by 1851 was living with his grandmother Mary Gosling in London Road (Ashbourne Road). By 1861 Mary had presumably died and he was living with his aunt Mary Ann Gosling, a milliner and dressmaker on London Road. Aged only fifteen, he was already a land surveyor's assistant. In 1871 James was living in the house of his uncle, John Broster, manager of a silk mill, at No. 17 Market Street. He was a land agent and surveyor and shared the house with a number of Broster family members, together with Mary A. Gosling, presumably the same aunt he was living with in 1861.

By 1881 he had his own house, No. 46 St Edward Street, which he shared with four cousins and two servants. Ten years later, still living in St Edward Street, Smith was unmarried and had an aunt and two cousins living with him, one of whom, James Broster, was his assistant. Apart from designing buildings he also seems to have acted as a property letting agent. One of the most notable buildings designed by J. G. Smith was for his relative William Broster and was the four-storey Waterloo Mill in Waterloo Street built in 1893–94. William Broster lived in King Street and was a silk manufacturer. Like most surviving Leek mills, Waterloo Mill is built of brick with stone dressings and has a slate roof. It is notable for its pyramidal copper spire on top of the central tower. The spire is now green with verdigris – like the dome on the Nicholson Institute used to be. The mill is visible from prominent points around Leek and is a good example of late nineteenth-century industrial building design. The Grade II-listed building has been converted into a thirty-apartment complex.

DID YOU KNOW?
Leek Town Hall, demolished in 1988, was not built as a town hall but as a private club and concert venue. The club failed after just four years and so the Leek improvement commissioners took the opportunity to buy the building and convert it into a town hall.

Above: James Gosling Smith's Waterloo Mill, built 1893–94.

Below: Victoria Buildings on Broad Street (1897) by J. G. Smith.

Victoria Buildings, on the corner of Broad Street and St Edward Street, was another of Smith's designs. Smith designed this grand half-timbered building for Henry Bermingham, whose initials appear above a small door on Broad Street. Henry Bermingham was another silk manufacturer, who lived at Lady Dale. Both Smith and Bermingham would be dismayed to see the state of this building now as instead of welcoming visitors to Leek with its grandeur, it looks sad and neglected with paint peeling off and wattle and daub falling from between the timbers. It has to be wondered how long it will be until main beams in the upper stories begin to rot resulting in huge restoration and repair costs.

On the opposite side of St Edward Street from Victoria Buildings is another of Smith's buildings, the Unicorn Inn, a large Arts and Crafts building, built in 1896 for Banks Brewery. Sadly, the Unicorn has been closed for three or four years and seems likely now to be converted to residential property. J. G. Smith died in 1897 and the writer of his obituary said, 'Mr James Gosling Smith was a man whom all knew and so highly respected. He never heard a word in all his life said against him. He knew him very well especially in the hunting field where his general manner made him many friends. He was an honest and upright man'. James Broster, Smith's assistant, took over the business but died suddenly aged thirty-two only a few months later.

The Arts and Crafts 'Unicorn' (1896) by J. G. Smith.

2. Leek Under the Ground

Speak to local historians and they will tell you that to see the history of a town, always look up; plate glass windows and automatic doors say very little about a building but look at the upper storeys, and there may be a date stone, a coat of arms or unspoiled architectural details that reveal much more about that building's, and possibly the town's, past.

The upstairs floors of buildings are not the only places where historic features can be found, in fact looking under the ground can reveal a tremendous amount of normally unseen history; this does not involve carrying out an archaeological dig, but simply by going down a cellar, or looking down into a hole.

Gone are the days of 'living over the shop'. In fact, in these times of national chains and buy-to-let property ownership, few people running shops actually own the buildings that house them. Upstairs floors, often let as flats, may retain features relating to former shop proprietors but cellars also reveal signs of former shopkeepers' lives. People today tend to shun cellars as 'creepy' places where various unpleasant animals such as rats and spiders live, although cellars rarely serve as homes for wild creatures at all and just exist as time capsules, ignored for decades. At the time when houses in towns were being converted into shops, there was suddenly a shortage of space for family living and so cellars took on a whole new lease of life; instead of being places to store coal, tools etc., they suddenly had to become living spaces. There are two kinds of underground rooms beneath shops and houses, those that have little or no light coming into them, and those which are not so much cellars as basements. This latter group usually have access from the pavement via steps leading down into an 'area'. Railings with a gate normally surround the opening in the pavement to prevent late-night revellers taking an unexpected trip 'downstairs'. The small flagged or tiled area was located outside the curtilage of the building and often had a room extending further beneath the pavement, in which there was a WC.

In Leek there are still areas and toilets like this, prime examples being in Sheepmarket, formerly Poyser's Hairdressers, and also, outside Leek, Pet and Fishing Centre in St Edward Street. In the former, the basement is unused but in the latter it contains the shop's fishing tackle department. Other examples can be found in Junction Road and King Street, where one house has its modern kitchen in the basement. Subterranean floors usually have windows opening into the area, these being necessary for ventilation and heat escape as well as for lighting. More interestingly they may also have old kitchen equipment in them, because if your shop, living room and stockroom were on the ground floor and your bedrooms on the first floor, the basement was the best place in which to store and prepare your food. The kitchen equipment found in these basements usually includes a fireplace, sometimes complete with cast-iron cooking ranges and adjacent bread ovens, sinks and shelving. Sometimes there is a brick structure in the corner with a fire hole and a circular hole in the top where a large 'copper' sat. A fire was lit underneath, which heated the water in the copper where the family's laundry was washed.

A cast-iron kitchen range with the pan still on the stove in Stanley Street.

DID YOU KNOW?
When private houses were converted into shops, cellars were often changed from coal and tool stores into rooms where food was prepared and laundry was done. Evidence for these changes of use still survive in many cellars including fireplaces, cooking ranges and sinks.

An interesting feature in Leek that cannot be seen from outside is where areas have been covered over, converting a basement into a true cellar. These cellars often still contain windows that look out into dark voids under the pavement. An example of this is beneath Bamboo in Leek's Market Place. No photograph has yet been seen showing this shop still with its area, so these windows were probably last looked out of around 120 years ago. True cellars are commonplace and may be found below many houses and shops throughout the town. Since coal ceased to be commonly used, even old coal chutes in these have been glazed or bricked up to keep unwanted items/animals out and to keep heat in.

Another interesting peculiarity to be found in Leek is where a basement has a true cellar beneath it. This is possible because red sandstone is located close to the surface and can be hewn out. There are reputed to be a number of these but in the one that has been

Windows in the dark for over a century, Bamboo, Market Place.

examined, the cellar was once fitted out as a gymnasium used by local fitness enthusiasts while business was conducted in the shop at ground level, two floors above. This cellar is now dry-lined and ventilated but unused. Even though regulations were passed in the 1840s banning living in cellars, as recently as 1891 in Leek, Thomas Walton (twenty-one) and his wife Mary (twenty-two) lived in the cellar underneath No. 7 London Street. Thomas was an unemployed silk picker and this home was presumably all they could afford. The house concerned has now been demolished making it no longer possible to see where Thomas and Mary used to live; it certainly couldn't have been very large or comfortable. It is the case that entire families could be found living in damp cellars. The following comes from a Sanitary Association report on working-class housing in the Deansgate area of Manchester: 'Cellar 3 is but one room about 12 feet by 14. There are two beds in the room. 7 people live & sleep in this one room. We could learn nothing more [because] a little girl only being in charge.'

If we look beneath the surface of most of Leek's streets, we will see original granite setts. People frequently refer to these small squared paving stones as cobbles but a cobble is actually a natural stone – like a pebble but larger; on a stony beach you can find both pebbles and cobbles. Cobbles were hammered into a medium called 'hoggin' (clay, sand and gravel) to produce a durable surface. Horses and carts would have rattled along these setts, in fact in these times of austerity and local authority cutbacks, the setts are all too often making themselves visible again through pot-holed tarmac. A few years ago, the full length of West Street was stripped back, providing a glimpse back to the 1920s. One surprising result of this was the greatly increased noise produced as motor cars travelled over the setts. Had Leek had trams like larger towns did, there would probably be redundant tramrails under the tarmac, but underneath Leek's roads are mostly services such as electricity cables, gas pipes, sewerage and the occasional culverted brook.

Most towns probably have culverted streams or brooks flowing beneath their streets and Leek is no exception. One such stream appears from a culvert next to Prince Street, having travelled under the houses in the Haig Road/Hall Avenue area. The stream then

Granite setts revealing themselves in Angle Street, 2016.

runs down the slope behind the Daisy Haye retirement development. At this point it is joined by a second stream emerging from a culvert and the two flow behind the houses in Rosebank Street The stream disappears underground again briefly before emerging from a pipe at Findlow & Sons and falling some distance in a containment area that looks as though it might once have housed a water wheel. Having disappeared again, it travels underneath houses in Ball Haye Road, under Vicarage Road and then under California Car Park and Brough Park on its way to the River Churnet.

According to Mrs Jean Fisher, the stream actually passed through the cellar of one of the houses in Ball Haye Road and the occupier of the house says that he thinks that this is true but that it had now been 'tanked'. Another such brook apparently passes beneath Brook Street, hence its name, and a former manager at Mason's Mill at the bottom of London Street remembers that it used to run through the cellar but within his memory was contained inside a pipe. A third stream must flow somewhere beneath St Edward

A brook flowing behind Rosebank Street on its way to the River Churnet.

Left: The underground toilets complex beneath the entrance to the Butter Market.

Below: The sealed entrance to the underground toilets at the bottom of Compton.

Street, formerly Spout Street. Sadly, Staffordshire Moorlands District Council seemed unable or unwilling to provide any details of these underground watercourses and, in the case of both Brook Street and St Edward Street, they are not visible at all above ground.

The building of underground public toilets in Britain began in the nineteenth century in places like London, where there was limited space aboveground on which to build, and large populations. This was clearly not true of Leek and yet four sets of underground toilets existed in the town. Underground toilets have now largely gone out of fashion because if not attended, which in these austere times they aren't, they are prone to vandalism, drug-taking or being used as venues for illicit sexual activity. There was always greater provision of public toilets for men than for women because men were expected to be out of the home for longer periods of time than women and there was generally a greater number of men on the streets. In Leek there were underground public toilets behind the public weighbridge at the bottom of Derby Street, both ladies and gents, underneath the entrance to the Butter Market, in Birch Gardens on Buxton Road and a final set at the bottom of Compton. None of these are still in use although the underground complex beneath the Butter Market still exists, now used for different purposes The toilets at the bottom of Compton also still exist although are now sealed up and all that can be seen now are the railings around them, the gate in those railings, the top step and some white ceramic tiles. Apparently these toilets remain in very good condition under the ground and are still inspected occasionally by council workers. They are possibly the most interesting in terms of how they came to exist; in 1909 when Compton was widened to cope with increasing levels of traffic, the Lord Raglan pub on the corner of Compton was demolished. It was decided that part of the old beer cellar would provide an ideal venue for public toilets.

DID YOU KNOW?
When houses or pubs did not have a tap connected to water mains, they would often have their own well either in a yard or garden, in the cellar, or even in one of the rooms. Even today in older buildings uncapped wells are occasionally found beneath floorboards.

As well as water going into the ground, it also used to be taken out and there are probably many wells still extant in Leek. The best-known one was discovered under the floor at 'Benks' (formerly 'The Union') in Stockwell Street. This has been built up from the ground and had a Perspex cover placed over it. When a light under the cover is switched on, it is possible to see the water far below. Other known wells are one in the entry next to Rymans, half built over by John Brealey's former house and one in a cellar in the Market Place. Another, now filled in, was in a Queen Street cellar and investigations might reveal signs of many more.

The term 'air-raid shelter' can cover a multitude of different kinds of structures and Leek's are no exception, despite the fact that neither Victoria County History nor

A well discovered under the floor at Benks', formerly 'The Union'.

Subterranea Britannica mention there ever having been any in the town. In fact, air-raid shelters are known to have been in existence at several Leek schools, including Leek High and Westwood First School where it is hoped that their shelters may soon be excavated from under the playing fields to show the pupils some of the harsh realities of life during the Second World War. A test pit has already been dug that has revealed some brickwork and a Second World War United States badge.

At the other end of the scale were domestic air-raid shelters that were not always of the corrugated-iron Anderson Shelter variety. Sometimes fathers would feel their family deserved something better and a 'proper' underground shelter would be constructed. A shelter of this type still survives in the West End of Leek with concrete steps down to an underground room with signs that a bench used to be attached to a wall there. Going further on the matter of escaping falling bombs, beneath the offices of Staffordshire Moorlands District Council is a nuclear fallout shelter dating back to the Cold War. This was originally a bank-vault used by the Leek & Moorlands Building Society but when the building society moved out and the council took over the building it was seen as an ideal location in which to create a bunker for senior council officials. The shelter was equipped with a dormitory where three of the original bunks remain in situ; these would sleep three people each and together with two bunks that have been removed, made a total capacity of fifteen people. There were shower cubicles, and a communications room. There were also one or two other rooms, one of which was probably for a scientific officer whose role was to monitor the safety of the shelter and decide when it was reasonable to leave, should it ever have been occupied.

School air-raid shelters being dug in the West End in 1939.

A home-built air-raid shelter in Spring Gardens.

> **DID YOU KNOW?**
> Cobbles are larger versions of pebbles and are found on beaches. They used to be used to surface roads when hammered into 'hoggin', a mixture of sand gravel and clay. They were replaced by small square granite 'setts' which could not easily be dislodged. What survives under the tarmac in Leek are not cobbles but setts.

Entry into the shelter was through a pair of very thick and heavy doors consisting of both lead and concrete and equipped with a 'peephole'. There is also a small hatch in the pavement to allow exit from the shelter into the street. There was storage for 2,500 gallons of diesel to run the electricity generator and a small filling hatch for this. The ventilation system was very powerful and is still used today. A number of pipes exit the bunker into the alleyway between the offices and Greystones but it is not certain whether these are exhausts from the generator or whether they are simply to allow breathed air to escape; Staffordshire Moorlands District Council have refused to allow any photographs to be taken or to provide any information about the bunker but its existence was publicised in a *Leek Post & Times* article on 6 July 2011.

Cellars sometimes contain items that have remained untouched for long periods of time; in a Market Place cellar is what appears to be a wooden board attached to the wall but when opened it reveals a drugs cabinet untouched since the cellar was abandoned decades ago. The bottles in the cabinet contain Delrosa Rosehip Syrup, Epsom salts, surgical spirit, nutritive salts and Brasso – the latter definitely not recommended for internal use. The most spectacular abandoned item though would require significant efforts to remove it. It is a cast-iron Columbian printing press dated 1862, probably purchased by George Hill, printer and stationer of Leek who operated from 1880, so it was presumably not new when he bought it. This highly decorative model of newspaper press is quite famous and many examples in working order can be seen in museums throughout the world. It was invented in the US in 1812 and a few were made there but most were manufactured in Europe, particularly in the UK. It seems that the machine was still in use until the 1960s or 1970s and still sitting on the machine is a frame containing the lettering to print a flyer: 'Football at Ball Haye Green Leek, Manchester League – Droylsden.'

Finally, a brief mention of the one underground feature widely believed in but extremely unlikely to exist: the supposed tunnel running from St Edward's Church to Dieulacres Abbey. The engineering feat involved in building such a tunnel – and no one ever seems to explain why such a tunnel would have been necessary – would have been enormous and no evidence of its existence has ever been found. True, there is a tunnel at St Edward's but this is widely believed to have given access to old family burial vaults, something which may one day be proven.

Right: A long-since abandoned medicine cabinet in a Market Place cellar.

Below: A Columbian newspaper press dated 1862. This was probably bought by George Hill.

3. Leek Through the Lens

Three men were vital in the development of photography: two Frenchmen, Joseph Nicéphore Niépce (1765–1833) and Louis-Jacques-Mandé Daguerre (1787–1851); and Englishman William Henry Fox Talbot (1800–77). Niépce produced photographic images as early as 1816 using paper coated in a light-sensitive silver emulsion but these images were negatives and not 'fixed', so when taken out of his apparatus they continued to react to light and turned completely black. In 1824, Niépce photographed a view from his house but this image was accidentally destroyed, so in 1826–27 he photographed the same scene again using bitumen-coated pewter. This image has survived and is the oldest-known photograph in existence. Niépce said the exposure had taken eight or nine hours but when his technique was tested later it was thought that it may actually have taken several days, not ideal for moving subjects or portraiture.

Daguerre, who had also been working on creating permanent photographic images, approached Niépce in 1829 and offered him a partnership. They worked together on a new technique but, after Niépce's sudden death in 1833, Daguerre went on to develop the daguerreotype, which he sold to the French government in return for a pension for life. Daguerreotypes continued to be used from the 1850s until the early twentieth century, even though by that time William Henry Fox-Talbot had developed better photographic

'View from the Window at Le Gras', by Niépce, 1826/27.

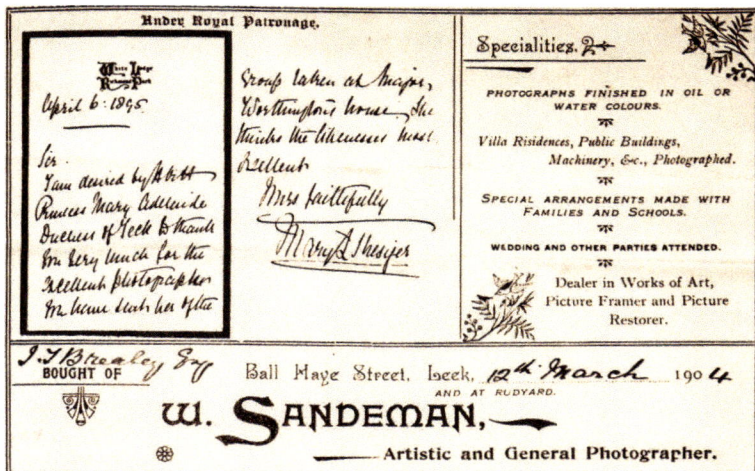

An invoice for photography from William Sandeman to J. T. Brealey, 1904.

techniques. Fox-Talbot, educated at Cambridge and living in a thirteenth-century abbey, was a scientist and inventor who began his photographic experiments around 1834 but then abandoned them for other projects. On hearing of Daguerre's success, Fox-Talbot resumed his experiments and managed to produce paper negative images that were light-fast ('fixed') and could be placed against another sheet of light-sensitive paper and illuminated, producing a permanent, positive image – a 'true photograph'. Initially, daguerreotypes were sharper than Fox-Talbot's images but this changed when glass rather than paper negatives were used and photographic papers were improved. The earliest English photograph, and probably the first ever photograph from a negative, was by Fox-Talbot of a window at Lacock Abbey, taken in August 1835. Fox-Talbot's experiments culminated in the photography used from the 1840s until the present day and in 1842 the Royal Society presented him with a medal for his achievements.

Photography became hugely important throughout the world and although initially the emergence of 'drawing with light' worried artists and portrait painters, fearing that they would lose their livelihoods to photographers, in many cases they seem to have countered this threat by becoming photographers themselves. Many early photographers were also artists, willing to overpaint their own photographs to produce lifelike images in oils; the rear of their photographs or their billheads often promoted these services, for example the invoice from William Sandeman to J. T. Brealey (above), dated 1904.

DID YOU KNOW?
The earliest photograph reputed to have been taken in Leek was of the old Black's Head, where Yorkshire Trading stands now. This ancient half-timbered building was demolished in 'about the year 1850', which would make this photograph extremely early, but no one today claims to have ever seen it.

Possibly a self-portrait of P. A. Rayner, Leek's first professional photographer.

Although at the time of writing a single social media site concerned with old Leek photographs has more than 3,000 members, it appears that little has ever been written about Leek's early photographers. The earliest reference to a Leek photograph comes from *Miller's Old Leeke*, which states that a photograph was taken by Revd F. Ribbands of the half-timbered Black's Head in the Market Place. This was demolished 'about the year 1850', meaning that the photo must have been exceptionally early and enquiries have yet failed to find anyone who claims to have seen it. There seems little doubt that the first professional photographer in Leek was Peter Ascough Rayner who, according to Gillian Jones' Staffordshire Professional Photographers 1840–1940, was described as such in 1860. He had been born in Bollington, Cheshire, but in the 1861 census was described as a master stationer and proprietor of a 'fancy repository' in Spout Street, Leek. He operated from No. 14 Spout Street between 1860 and 1864 and then from No. 14 St Edward Street between 1868 and 1884. This was actually the same shop, indicating Spout Street's change of name between 1864 and 1868. Rayner's shop is currently being renovated but was previously John Worthy's art gallery. Mr Worthy said that when he moved in there was still evidence of a photographic darkroom, lit by an oil lamp, in the attic.

The earliest Rayner photograph seen so far (and therefore also the earliest-known Leek photograph) is a Carte de Visite (CdV) of Rose Worthington and dated on the rear March 1867; Rose was the daughter of Andrew Jukes Worthington, a silk manufacturer and later Commanding Officer of the Leek Rifle Volunteers. In 1861, the Worthingtons lived in Spout Street but by 1871 had moved to Ball Haye Hall, by which time Rayner was a photographer first and foremost but also a music seller, bookseller and small-ware dealer. There seems to have been a strong connection between Rayner and the Rifle Volunteers and he was often involved in their activities, although he never seems to have been a member. At some time, the rear of Rayner's Carte de Visites began to state that he was patronised by the Prince and Princess of Teck, who had visited Leek and the Roaches

Left: P. A. Rayner's former premises at No. 14 St Edward Street.

Right: Carte de Visite of Rose Worthington by P. A. Rayner, March 1867.

on 23 August 1872. A photograph of this visit is included in an album of photographs, believed to have all been taken by Rayner, in private ownership. It must be assumed that Rayner had either been granted permission to photograph the royal party at the time of their visits, or had perhaps just taken the photos and sent free copies to the family. Receipt of a thank you letter, might then be used to suggest being patronised by them. Rayner also claimed the earls of Shrewsbury and Macclesfield as patrons. The Earl of Shrewsbury, Maj. Charles Henry John Chetwynd-Talbot, had strong connections with the area, being the owner of Alton Towers, and the Earl of Macclesfield was descended from the first Earl who had been born in Leek and whose family still owned a great deal of property in the area.

In 1881, Rayner was still at St Edward Street where he was listed as a photographer and parcel agent. It is in the 1870s and 1880s that Rayner took his best photographs, including portraits of many of the influential people of Leek and also of buildings and events. Towards the end of his life, Rayner seems to have abandoned photography in favour of being a full-time parcels agent. In Ray Poole's *Leek Trade Bills: Vol III*, a memorandum from Rayner shows that he was a 'Photographer, Music Seller, Stationer and General Dealer' and also an 'Agent for Sutton & Co. General Carriers'. The cover photo of *Leek Through Time* (N. Collingwood) shows a shop on the corner of Stockwell Street

and New Street bearing both Rayner's and Sutton's names on the frontage and reveals that, as well as being able to arrange to have goods sent from there to 'all parts of the world', you could also get your harmonium or pianoforte tuned or repaired! Rayner was clearly a musical man and in 1887 was responsible for conducting the hymn-singing in the Market Place on Queen Victoria's Jubilee. Rayner and his family later lived in Queen Street and, upon his death in 1892, he was described simply as a 'parcels agent'.

In business as a Leek professional photographer shortly after Rayner was Henry Wardle of No. 46 West Street, first listed as such in 1861. This address is actually the Britannia Inn and it appears that, like Rayner, Wardle had two separate occupations. Taking photographs during the day and serving drinks at night may have provided Wardle with a steady stream of portrait and commercial customers. By 1872 Kelly's Directory listed Henry Wardle simply as a beer and wine retailer, so perhaps his photographic career was fairly short-lived. Wardle was clearly a successful entrepreneur as he later formed a partnership with George Davenport to make textiles. The partnership of 'Wardle & Davenport' blossomed into one of the largest manufacturing companies in Leek, employing 600 people by 1968 before going into liquidation in 1970, almost a century after it started.

Photographer William Sandeman, originally from Forfarshire in Scotland, settled in Leek and opened a photographic studio together with Mr Hodgson at No. 3 Ball Haye Street in 1884. They also opened another studio in Rugeley some 30 miles away but the Rugeley studio closed after only a short period and Sandeman continued to work alone in the Leek premises. Professional photography was not available to everyone and, in 1886, Sandeman and Hodgson were advertising their new imperial photo Carte de Visites 'from 6/- per dozen'. At a minimum of 6d each, these were quite a luxury considering that they were intended to be given away or left at a house to which an unsuccessful visit had been made. Sandeman & Hodgson were also seeking agents, presumably to sell both their services and their existing postcards. In around 1895, the Sandemans moved from Leek to Rudyard and when the North Staffs Railway began to develop Rudyard Reservoir as a tourist attraction, Sandeman was ideally located to cash in on selling 'real photo' postcards of Rudyard's events and attractions. According to a billhead of 1895, Sandeman was operating from both Ball Haye Street and Rudyard simultaneously, and kept his Leek studio open until around 1905. Initially he produced his postcards in-house but, unable to keep pace with Rudyard's popularity, began to outsource the cards to a printer in Saxony. This continued until around 1911 before he again changed publisher to the Doncaster Rotary Photo Company ('Doncaster Rotophoto') who produced sepia-toned cards of his images until the 1920s. The last set of cards he had published was in January 1922 but these were of poor quality and shortly afterwards Sandeman retired. Following his death in 1928, Sandeman's family obeyed his instructions to destroy all of his glass-plate negatives by throwing them down a dry well.

In 1924, nineteen years after Sandeman had closed his studio in Leek, photographers Brown and Davenhill were operating from No. 3 Ball Haye Street and in 1928 Herbert Brown was there by himself. It seems that photographic premises routinely passed from one photographer to another rather than being refurbished for entirely different uses when their previous occupiers moved out or died. Photographer's premises were

presumably sold on the basis that they were already equipped with a studio and a darkroom and were 'ready to go'.

In 1891, Harry Follows Phillips lived with his parents at No. 19 St Edward Street – a very striking house that Niklaus Pevsner described as 'late c18, richly but oddly decorated'. By this he is probably referring mainly to the very elaborate front door with its two decorated pillars. Although largely restored fairly recently, it has now stood empty for a number of years. Harry Phillips' father ran a drapery shop and Harry worked there for him as an assistant. By 1901 Harry's father had died and Harry was listed not as a draper but a photographer, as he was in 1911.

An interesting feature of Phillips' building is the large glazed section at the front of the roof, which would have been installed either by Phillips or by one of his successors, to light a studio. The fact that Harry conducted his photographic business there and must have installed a studio and darkroom probably explains why two other photographers (Edith Barlow and Frank Bradley) later occupied the same property at different times. Phillips was an extremely competent photographer and produced some very high-quality street scenes, such as the photo of Derby Street (*see* 5. Leek Though the Post), as well as portraits. At some point during the Second Boer War (1899–1902), he took a photograph of a dog wearing a blanket with a box attached to it, bearing the word 'Help'. The dog stood on a table covered by a Union Flag and large numbers of prints were made to be sold to raise money to send a 'good supply of tobacco' to all the Leek soldiers fighting in southern Africa. It seems that if the Boers didn't kill you, the tobacco might.

Number 19 St Edward Street, which was occupied at various times by three different photographers.

Harry Phillips' picture 'Help' raising money for tobacco for Boer War soldiers.

DID YOU KNOW?
Leek's first professional photographer was almost certainly Peter Ayscough Rayner who set up in the town in 1860. Rayner took a great many of the well-known early photographs of the town.

William Henry Horne is another well-known Leek professional photographer. He was listed as a photographer in the 1891 census when he was staying as a visitor at Alstonefield and by 1892 was in occupation at No. 71 Derby Street. Between 1896 and at least 1944, he was at the single-storey No. 69 Derby Street, now Graham Watkins estate agents, and a postcard of the bottom of Derby Street taken in the 1940s shows Horne's shop. In the *Post & Times* of 22 March 1941, it was reported that 'considerable damage was caused to a photographer's studio when at least three German firebombs penetrated the roof. The rear of the premises were completely destroyed and expensive cameras and equipment were lost in the blaze. Although censorship didn't permit the premises to be named, Ray Poole later identified these premises as Horne's. The studio at Horne's was clearly not all that large because in 1944 a disagreement took place at the marriage of the author's parents, F. W. Collingwood and D. A. Vernon, when Mr Horne, by this time in his eighties, said that there were too many people in the wedding group. The people in the group said that that was how many there were and so he would just have to fit them in (the bride was one of seven children and the groom one of four plus two adoptees). Horne lived for a

Above: Derby Street in the 1940s, with W. H. Horne's 'Fine Art Photography' studio visible to the right.

Right: Bertie Moreton Holman by Edith L. Barlow, 1920.

time in Grosvenor Street but later moved to the Brooklands, Ashbourne Road, his address at the time of his death, aged ninety-five in 1956.

Edith L. Barlow is the only female professional photographer to have been identified in Leek in these early years. She followed Harry F. Phillips into No. 19 St Edward Street between 1916 and 1924. Harry Phillips had died in 1913 and perhaps there were better opportunities for a female photographer to take portraits of ladies and children. Edith had been born in Leek and in the 1911 census was aged twenty-three and working as a photographer's assistant, an occupation she had taken up after 1901. Another photographer, Frank Bradley, was occupying the same premises by 1928. The only Frank Bradley located in Leek in the 1911 census was not described as a photographer, but on 11 November of the same year an F. Bradley won a Certificate of Merit in a Leek Photographic Society competition. Two weeks later, he gave a successful demonstration of the autotype carbon printing process so it would appear that he was a keen amateur who turned professional.

A significant force in Leek photography was George Hill who founded a printing and stationery business in Stanley Street in 1880. The business became George Hill & Sons between 1901 and 1907 and the Hill family was responsible for producing huge numbers of 'real photo' postcards of Leek and the surrounding areas. These cards were produced from half-plate glass negatives, many of which have survived in private ownership to the present day. They include many well-known images such as the photographs of the Leek battery passing Lowe Hill Bridge on Ashbourne Road in 1914. The Hill business was sold in 1940 but continued to trade under new owners until the 1970s.

Boxes of George Hill & Sons glass negatives.

4. Leek Through the Window

We take windows for granted today but perhaps we should stop and think about how the wonderfully versatile substance of glass ever came to be manufactured from such an unlikely raw material as sand. Glass is made by melting together several minerals at very high temperatures. Silica, in the form of sand, is the main ingredient and this is combined with soda ash and limestone and melted in a furnace at temperatures of 1,700°C. Other materials such as metallic salts can be added to produce different colours or properties. The earliest windows in England were just openings in the wall and while they did allow in small amounts of light, they also admitted sound, smells and, perhaps more crucially, missiles such as arrows. They also allowed the escape of heat, something hard-won in castles and early houses. For these reasons, early windows were very small and sometimes, for defensive purposes, no more than slits. In more peaceful times, linen, made translucent by soaking it in linseed oil, was stretched across the openings. A rather more robust alternative to this was to use flattened sheets of laminated animal horn, a fairly pliable substance but laborious, messy and very smelly to prepare. While both of these materials allowed light in, they did not allow those inside to see out.

Although glass windows had been manufactured by the Romans in Egypt as early as the first century AD, here in England they did not become even remotely common for another 1,600 years. A very small number of private individuals and churches had them in the intervening period but they were so expensive that when moving house, private owners would often take their windows with them. Early English domestic windows were designed to allow light into buildings but also to keep heat in; they were made of small pieces of glass held in place by lead strips – so-called lattice windows. The earliest surviving image taken by photographic pioneer William Henry Fox–Talbot (*see* 3. Leek Through the Lens) was of just such a window at Lacock Abbey. Windows of this date gave a much clearer impression of what was happening outside but their optical quality still left much to be desired and late nineteenth-century glass still in situ today often gives a rather distorted view of the world.

Once the manufacture of clear glass and its use in windows was commonplace, it also began to be used for decorative and advertising purposes. Stained glass had begun to be

DID YOU KNOW?
The earliest recorded glass in Leek was that from the thirteenth-century Dieulacres Abbey but the whereabouts of even broken fragments of that seem to be unknown, despite some having reportedly been found on site in the nineteenth century.

Above left: A glazed door from Poyser's hairdressers in Sheepmarket.

Above right: A window from the old Leek Conservative Club, Church Street.

used in English churches as early as the seventh century and by the twelfth century had become a sophisticated art form. Leek has a number of fine stained-glass church windows with perhaps the best known being those in All Saints' Church, built by (Richard) Norman Shaw in 1885. This is a Grade I-listed Arts and Crafts building and many of the windows were made by William Morris & Co., to designs by Edward Burne-Jones. Some of these windows can be seen without even entering the church as they are located in the south porch. The Burne-Jones ones depict St Martin and St Helena on the west side and on the east side Christ, St John the Evangelist and Martha and Mary of Bethany. Sadly, some of these windows were recently vandalised and had to be restored and afforded better protection from further attacks. Interestingly, Leek's oldest church, the parish church of St Edward the Confessor, contains no medieval stained glass and the manufacture of the earliest glass, installed in 1867, was put out to tender, the final decision seeming to have been based on cost rather than proven quality. For this reason, much of this glass has deteriorated badly and lost its detail. More detailed information and photos of Leek's stained-glass church windows are generally available in church guidebooks.

Later on, it was not just churches that used stained or painted glass; when Leek Conservative Club was built in 1887, it had windows bearing the initials 'LCC'. Fortunately when the building was demolished in 1972, along with the other buildings on the south

Christ by Edward Burne-Jones, All Saints' Church porch.

side of Church Street, one of these windows was removed by a former employee and survives today in private ownership. Another example was the glazed door to Poyser's hairdressers in Sheepmarket. The glass bore the words 'Poyser's Hairdressing Salons', of which there were two in Leek, and 'Est[ablished] 1837'. The glazing was commissioned by Victor Poyser, who owned the shops, the one on Ashbourne Road being run by his son Allan. When the shop in Sheepmarket closed its doors in 2015, the door was retained by Victor's great-grandson prior to the property being sold and will hopefully be installed at his house.

A further example of advertising glass is an oval window located in a gable above Leek Town Council's offices in Stockwell Street. This building, designed by J. T. Brealey, was formerly the offices of the Leek & Moorlands Building Society and the window contains their intertwined initials. On the rear wall of the same room is another stained-glass window, which looks quite modern although it is actually more than a century old. It seems to represent the rising sun.

The former Leek & Moorlands Building Society window, Stockwell Street.

Rising Sun on the former Leek & Moorlands Building Society, Stockwell Street.

DID YOU KNOW?

The term 'stained glass' can refer either to a mix of glass coloured by adding metallic salts to it, or glass that has been painted with a pigment made from metallic salts, which is then baked on to the surface.

Ford House on the corner of Market Street and Stockwell Street was built in the early 1700s and was the home of the Ford family and later the Sneyds, who still own it, and is now the registered office of Fearns Marriott accountants. It was extensively remodelled in the late nineteenth century and the work is believed to have been done by (William) Larner Sugden. The remodelling involved the installation of a full-height painted glass stair window. This window depicts watery habitats in North Staffordshire: the rivers Churnet, Dove, Dane and Manifold and also Blakemere Pool and Rudyard Reservoir. The Rudyard panel is informative in that it proves without a doubt that the window dates from the very end of the nineteenth century because, behind the bare-bosomed woman shown in colour in the foreground, the same woman in monochrome can be seen on what is undoubtedly the Lady of the Lake boathouse. This boathouse was built for the Davenport family in 1893, so the glass must post-date that year. The boathouse was

Left: Larner Sugden's Lady of the Lake window at Ford House.

Right: Larner Sugden's Leek Commercial halfpenny window, NatWest Bank.

designed by William Sugden & Son, although William himself had died the previous year. It must therefore have been Larner Sugden who supervised its building and by the image being present in the window at Ford House Sugden seems to confirm his involvement in the remodelling. Other unusual and high-quality Sugden painted glass windows are in what was built as the Manchester and Liverpool District Bank, now the Natwest Bank in Derby Street. In windows facing out on to the street is a representation of both sides of the Leek Commercial Halfpenny. These coins were struck in 1793, together with similar tokens all over the country. They were not made by the Royal Mint and were for use only in Leek.

Some of the most interesting and possibly most mysterious painted glass in Leek is not generally visible to the public. This glass is located in three houses in St Edward Street: No. 58, Les Hetres; No. 64, 'Silken Strand'; and Nos 66 and 68, 'Spout Hall'. These houses are all associated with Hugh Sleigh, a silk manufacturer, and as the glass in all three has been installed in the same way and appears likely to have had a common source, it seems undeniable that Sleigh was the man responsible for its presence; there is further concrete evidence within the glass itself that this is so. It seems likely that there is a connection between this glass and the proponents of the Arts and Crafts Movement: (Richard) Norman Shaw, and Edward Burne-Jones. Norman Shaw is known to have built Spout Hall and may also have built Les Hetres (The Beeches) although this is not proven. What is rather surprising is that the stained glass in these houses is mentioned briefly in several local history books but none of the authors have ventured to comment on where it came from or even what is depicted in it, which seems a sad oversight. Stained glass in churches is often well documented, often in the windows themselves, but the glass in St Edward Street seems to be completely anonymous, except perhaps to experts in the field.

Starting with the lowest of the three buildings, Spout Hall is the pair of half-timbered houses, now divided into flats, built for Sleigh to the design of London architect Norman Shaw in 1873. The building has a stone-built ground floor with projecting timber-framed upper stories. It is a 'black-and-white' house sometimes referred to as Queen Anne Revival with the lofty chimneys, so typical of Shaw's early houses, rising from its roof. Shaw was a member of the Royal Academy and was responsible for designing many much-vaunted buildings throughout England, including the former New Scotland Yard on the Thames Embankment. Later renamed the Norman Shaw Buildings, it now serves as parliamentary offices. Shaw met Sleigh through a mutual Staffordshire friend and was responsible for building St Matthew's Church at Meerbrook and later All Saints' Church in Leek.

In the front windows of the principal rooms of both halves of Spout Hall is a series of painted glass panels depicting early kings of England, including Henry VI, Edmund Ironsides and 'Edgar Rex'. From the outside, no detail can be seen of the glass other than that they are crowned busts, but from the inside they become detailed and richly coloured. The panels appear likely to have been made specifically for these windows as Norman Shaw was known for his use of Pre-Raphaelite stained glass. It is on the first floor of No. 68 where the glass becomes more interesting and a challenge for anyone who enjoys a good puzzle. In the middle of the top lights are four lozenges of glass painted with rather crude representations of plants. Surrounding these are fragments of painted glass depicting a vast range of subjects, including heraldic devices such as fleur-de-lys,

'Edgar Rex' window at Norman Shaw's Spout Hall.

and the Prince of Wales crest. There are many more fragments of flowers and foliage and even a small piece of a landscape looking across a bridge. Some attempt has been made to organise these fragments, with pieces from 'matching' designs being used in each corner but it is largely a jumble.

The quality of the painting also varies hugely with some representations being very crude and two-dimensional and others beautifully painted with fine detail and shadows making them appear three-dimensional. Could they perhaps be deliberately broken apprentice's pieces coupled with shards by top glass-painters that had been produced for specific commissions but then accidentally broken? In No. 64 (Silken Strand) there is a huge area of coloured glass on a first-floor landing and here many of the windows bear shields of arms in their centres with broken fragments, as in Spout Hall, surrounding them. It is incorrect to call these coats of arms, as coats of arms were embroidered on to a surcoat worn over armour and were usually more elaborate than arms on a shield. In some of these windows, the areas surrounding the central motif are filled with panes of flowers painted only in yellow/gold. This matches very closely the technique used by Morris & Co. in their windows in the chapel of the Royal Cheadle Hospital in Manchester.

Some of the arms have been identified: the chevron with three leopards' heads of the Parkers (Earls of Macclesfield). The Dampiers (demi-lion rampant with a ducal coronet) with the family motto '*Dominus petra mea*' – 'God is my rock'. Also here is the arms of the Sleighs themselves, a chevron with three owls, these arms being carved in stone on the front of both Spout Hall and Les Hetres. The name Sleigh appears in many of the pedigrees researched by Hugh Sleigh's brother John in his *History of the Ancient Parish of Leek* (1883) and an interesting fact revealed in Beryl Johnson's *Old St Edward Street, Leek* is that the Sleighs were connected with the Parkers and the Dampiers, whose arms are in No. 64, and also the Whillocks and the Batemans, whose arms appear in Les Hetres.

> **DID YOU KNOW?**
> Before glass was used in windows, linen soaked in Linseed oil to make it translucent was used. An alternative was de-laminated and flattened animal horn, a very messy and smelly process to carry out.

Perhaps all of the arms shown are families to whom the Sleighs were connected by marriage; if they are simply arms of the major families in the area, it is perhaps surprising that so few of the ones in the windows appear in John Sleigh's book. In Les Hetres, the house that Hugh Sleigh had built and was lived in by his son Hugh Richard ('Hugo') and his family, there is again a wealth of coloured glass; on a first-floor landing is a set of high quality Arts and Crafts panels depicting the seasons: a blonde haired girl sowing seeds from a basket (Spring), a young man who has caught a large fish (Summer), a man in working clothes holding in one hand a sheaf of wheat and in the other hand a sickle (Autumn) and finally a cloaked and cowled man gathering sticks for the fire (Winter).

In the rear windows of the principal rooms, looking out over the garden, are windows with 'shields of arms' surrounded by broken fragments and other windows constructed entirely from broken fragments. St Mary's Church, Wreay in the Lake District, uses exactly the same technique of a central motif surrounded by shards of recycled glass and possibly this technique can be found elsewhere. The fragments show both real and mythical beasts, fish, ostriches, songbirds and unicorns, partial portraits, plants and flowers. When compared with the illustrations in John Sleigh's book, the arms of Bulkeley (three bulls), and Whillock (crowned lion with chequered bar across) can be seen and also identified is the muzzled and chained bear of the Beresfords, another family with which the Sleighs were linked. It is in a bathroom though where a more obvious link between the glass and the Sleighs can be found. Here stands a tall bearded knight in armour, one of several in

Blonde girl sowing seeds, representing spring, at Les Hetres.

A window made entirely from broken stained-glass fragments at Les Hetres.

A knight bearing a shield adorned with the Sleigh arms at Les Hetres.

the house, with a sword in his right hand and in his left a shield bearing the Sleigh arms. On the front of Les Hetres, the Sleigh arms are surmounted by a demi-lion and supported by the motto '*Sapere Aude*'. This has previously been translated by a local historian as 'listen to know' but actually means 'dare to know' or 'dare to be wise' and is attributed to Horace around 20 BC. This seems to tie in with the use of 'wise' owls on the Sleigh arms. As with the pronunciation of Strangman vs Strange-man Street, pronunciation of the name Sleigh seems to have two camps, those supporting 'Slee' and those opting for 'sly'. If we consider though that the word 'sly' was not always a derogatory term but merely meant wise in battle and tactics, perhaps this is a clear indication that the correct pronunciation should be 'sly'.

5. Leek Through the Post

Many people are under the impression that the English postal system started with the introduction of the Penny Black postage stamp in 1840, but this is actually very far from the truth; in fact there was a Royal Mail as early as 1507, two years before the coronation of Henry VIII. It was run by Brian Tuke, who was appointed Master of Posts by Cardinal Wolsey and the system was put in place to send out edicts from the king to his subjects. Tuke had worked in Calais, becoming familiar with the French postal system and so introduced a similar arrangement to England, establishing key post towns across the country so that the provinces could quickly be made aware of the royal decrees. To enable speedy delivery, letters were carried by individual horsemen, the fastest mode of transport available at the time. More than a century later in England (1635), Charles I opened up Royal Mail to the general public so that ordinary people could have their letters and parcels delivered by mounted 'post-boys'. What should be remembered is that 'ordinary people' largely could neither read nor write and so the nobility, gentry and professionals such as doctors, clergymen and lawyers would have been the main beneficiaries of this service.

Initially letters were delivered to the local postmaster (or mistress) in the main post towns but this was later extended to all towns of a reasonable size and Leek had a postmistress by 1776. Having been delivered to the postmaster, letters then had to be carried to their intended recipient using a separate independent delivery system and in 1765 Parliament authorised the setting up of 'penny posts', allowing mail to be delivered throughout a town for a fixed fee of one penny. A similar system had been established in London in the 1600s but this had been closed down by the king when it was discovered that it was being used for delivering anti-royal material.

As roads were improved by being 'turnpiked', the post began to be carried by 'mail coaches' rather than individual riders and Leek found itself directly on the route of the London–Manchester mail coach, established in 1785. Mail from Leek would be sent from the post office in Market Place, which in 1822 was run by the unusually-named John Smith. In a description of an incident involving a French Napoleonic prisoner, M. H. Miller's *Leek Fifty Years Ago* seems to inform us that the post office was on the corner of Market Place and Derby Street, in the shop now occupied by the Home Boutique. At that time a

DID YOU KNOW?
Royal Mail did not come into existence in 1840 when the Penny Black postage stamp was introduced as many people believe; it actually began in 1507, during the reign of Henry VII.

mail coach left for London at 11 a.m. and for Manchester at 2 p.m. every day. Interestingly, there was no mention of mail arriving from those places but it probably arrived on the same coaches, which then returned following a break for the coachmen and a change of horses.

By 1829, Leek's post office was in Spout Street (later St Edward Street) and was run by Catherine Williams, who held the position for around six years. Catherine and Ann Williams were also boot and shoe dealers and so it appears that, as with photographers, postmistresses tended to have a second occupation. Now, as well as the mail coaches, there was also a 'horse post' to 'Warslow, Longnor, Hartington etc' three times a week. The roads to these rural areas were presumably too poor for the use of wheeled vehicles for deliveries. There may well then have been a further penny post charge from the postmaster/mistress in the village concerned meaning that there was probably a significantly higher cost involved in delivering a letter to a rural address.

George Nall came to Leek from Bakewell in the 1820s and set up shop in Spout Street. By 1842 Nall had moved to Sheepmarket and his shop there was a bookseller's, stationer's and printer's and in that year also became the post office. Nall was also a stamp distributor, the Penny Black postage stamp having been introduced two years earlier, on 1 May 1840. Three years earlier in 1837, Leek's post office was supplied with a dating stamp so that it could be seen on what date a letter had been put into the post – postmarks pre-date stamps! Nall was an important man who seemed to have his fingers in a great many pies; he would print anything he was asked to: satirical anti-Conservative Party election posters for the general election of 1832; he sold patent ('quack') medicines and was a member of various committees. He was also the first churchwarden of St Luke's Church. In 1843, Nall moved his printing business and post office to Custard Street (Stanley Street) and he was still at No. 11 nearly thirty years later (1868).

There had clearly been changes in the nature of the Post Office though as it was now called the Post Office Savings Bank and Government Annuity Office, where, apart from

George Nall's window inside today's Den Engel.

dealing with mail, money orders could be granted and paid every day except Sunday. Post delivery times had changed too and become more complex, probably because the arrival of trains in Leek in 1849 allowed for more flexibility. According to Cathryn Walton in *Hidden Lives*, Nall's position as churchwarden enabled him to acquire some 'left over' stained glass from St Luke's, which he had fashioned into a panel bearing the initials 'GN' that was placed over the door of his house/shop (now Den Engel) and there it remains to the present day.

Another significant development in mail delivery that took place under Nall's watch was the introduction of post (pillar) boxes, first seen in mainland England around 1853 after visitors to France in *c.* 1850 had seen them in use there. There was a small trial of just four boxes in Jersey, after which they were introduced to Britain generally. In its Post Office information, Kelly's Directory of 1896 included a list of ten pillar boxes situated in the town. These were in busy locations such as St Edward Street, Derby Street and at the railway station. Initially, postboxes were designed by local surveyors, meaning that there was no consistency in their design; some were round some square but they were all initially painted green. The oldest surviving postbox within close range of Leek is of the wall-mounted type on Abbey Green Road, near the Abbey Inn. It was made for, or by, W. T. Allen & Co. London and bears the letters 'VR' (Victoria Regina) at the top, on either side of a queen's crown. The most notable recent postbox is the one in Derby Street, quite close to the location of the 1880s post office, which was painted gold in 2012 to

Left: Victorian postbox on Abbey Green Road.

Right: A gold postbox commemorating Anna Watkins' London 2012 gold medal.

commemorate the victory of Leekensian Anna Watkins MBE (together with Katherine Grainger) in the London Olympics double sculls rowing event. As well as winning the gold medal, the duo also broke the Olympic record for the distance in the semi-finals.

> ### DID YOU KNOW?
> When post, or 'pillar', boxes were first introduced in the 1850s, they were designed by local surveyors and so did not have a standard form. The standardisation of pillar boxes only occurred in 1879. What *was* standard from 1859–74 though was their colour – green!

George Nall later moved to Great Yarmouth to run a printing business there (but not a post office) and seems to have sold his printing business to William Clemesha. It was Samuel Tatton who became Leek's new postmaster, in charge of what had once again changed its name to the 'Post & Money Order & Telegraph Office' at No. 11 Stanley Street. A list of telegraph offices that were already operational in 1862 included Leek but it is known that the railway station was equipped with telegraph capabilities so it seems likely that another telegraph machine was installed in the post office at around the time that Tatton took it over. Samuel Tatton was not attributed with another line of work so perhaps running the post office had now become a full-time occupation. Tatton was still postmaster in 1880, the main difference in Post Office operations being that 'walking postmen are dispatched to adjacent villages at 6:30 a.m.' These walking postmen were out in all weathers and sometimes covered astonishing distances every day on their

Munro's, formerly George Nall's Post Office, and now Den Engel.

Phillips' photo of the post office on the corner of Derby Street and Russell Street.

rounds. By 1880, Tatton had moved his post office to St. Edward Street and then made a further move to the corner of Derby Street and Russell Street by 1884. While earlier post offices may show up on old paintings or drawings, the first operational post office that shows clearly in a photograph seems to be this building, later occupied by John West's, the ironmonger and agricultural merchant, and now by the Halifax Building Society. According to G. A. Lovenbury, the architects of this building were William Sugden & Son, whose offices were on the opposite side of the street, now occupied by Boots. In a superbly evocative photograph by Harry Follows Phillips, a gas lamp standard can be seen outside the building bearing the words 'Post Office' and this is also visible above the door.

Around 1905 an attractive purpose-built General Post Office (GPO) was built on the corner of St Edward Street and Strangman's Walk , the east end of which was widened at this time and renamed Strangman Street. This striking building was also stated by George Lovenbury to have been designed by William Sugden & Son Ltd, although at the time of building William had been dead for thirteen years and (William) Larner for four years. It is of course possible that the Sugdens designed the building but that there was a delay before it was actually built. The post office replaced the Black Lion public house and two shops adjacent to it.

By 1912 the official name of the Post Office had become nearly as long as some of the walking postmen's rounds, now being called the 'Post, Money Order & Telegraph Office & Telephone & Telephonic Express Delivery Office' – you can be fairly sure that ordinary people still referred to it simply as the Post Office.

The 1905 post office in St Edward Street, attributed to Sugdens.

The postmaster's parents also seemed to have favoured long names as his name was Thomas John Picton Sloggett. He had been in post at least since 1911, having moved to Leek from Cardiff. More major changes took place in the post office by 1916 as, in addition to the main post office in St Edward Street, Leek also now had post offices in Ball Haye Green, Mill Street, South Bank Street and West Street. The head postmaster was another long-named man: Reginald Arthur Brame Abbott. The Mill Street sub-post office was captured on a photo from around that time with a fantastically dressed couple, presumably Mr Hutchinson, the postmaster, and his wife standing outside the premises.

In 1964, a new, modernist post office was built higher up St Edward Street bearing the legend EIIR under a queen's crown (representations of the crowns for kings and queens of England are slightly different) and the date 1964 in gold leaf inscribed into black marble next to the door. A few years later (1967–68), the previous post office was demolished and replaced by a Standard Trunk Dialling (STD) telephone exchange, built in the same style as the 1964 post office and still in use in 2016. Sadly the 'new' post office only remained in use until July 1993 and now stands forlorn with filthy windows. As with most disused post offices, it still retains its pillar box outside.

Until very recently, peering through the windows revealed the old public area with its counters still in situ but now used only as a storage area for parcel trucks from the sorting office at the rear. It seems long overdue that this building, or at least its ground floor, be liberated for other purposes having stood empty for more than two decades. After the St Edward Street office closed, the post office transferred to Genie's lighting shop in Hayward Street where Thai restaurant 'So Thai' stands today.

Above: South Bank Street Post Office *c.* 1906 (closed 2004).

Below: The Mill Street Post Office, with a couple who are likely the postmaster and his wife outside.

Above: The 1964 post office, St Edward Street, closed in July 1993.

Right: The inscription next to the 1964 post office door.

Today Leek has just two post offices: one inside the Waitrose supermarket on Buxton Road and the other on Westwood Road, both of which are classed as main post offices; the popular South Bank Street post office having closed in 2004. This reflects the general decline in post offices throughout the UK, which have almost halved since the early 1980s, from 22,500 to about 11,500 in 2014/15. Post Office Ltd say that they are committed to maintaining the remaining post offices although they now manage only 3 per cent of the ones that do exist, the rest being private franchises. It seems likely that this privatisation of post offices will continue until they have all been franchised.

DID YOU KNOW?

Many buildings and sites in Leek have at one time or another been the town's post office: Home Boutique, Den Engel, the Halifax Building Society, the site of the present Telephone Exchange, the 1964 post office and So Thai in Hayward Street, together with an unknown shop in Sheepmarket and another two unknown premises in St Edward Street.

6. Leek Behind Bars

The Staffordshire Police force was formed following a meeting held in October 1842. There were two main reasons why a trained countywide police force was considered necessary: firstly because of increasing criminality, which traditional parish constables, who often also carried out roles such as lamp-lighting, were unable to deal with; and secondly because of the rise of the Chartist Movement.

The Chartists aims were to obtain greater political and social rights for working men, many of whom lived in poverty and were incapable of improving their situation because they had no vote and because they were under the total control of 'the masters', who could, and would, reduce their wages at will. Three petitions of between one and three million signatures were presented to Parliament between 1839 and 1848, demanding greater equality but these were overwhelmingly rejected by the wealthy industrialists and landowners who made up the government. Violent protests resulted. Land and business owners were afraid of this unrest and so were active in promoting a trained police force to protect themselves. Two months after the meeting, John Hayes Hatton, aged forty-seven, was appointed Staffordshire's first chief constable. As he had successfully established the Sussex Police two years earlier, he came to Staffordshire with proven credentials.

Under Chief Constable Hatton's direction, new recruits were trained in Stafford Prison yard before being posted to one of three policing 'districts'. The organisation of these districts presumably reflected the relative levels of lawlessness across the county and the activities of the Chartists; there was a 'mining district' covering places such as Bilston and Dudley, a 'pottery district' including the six potteries towns and a 'rural district' consisting of the remainder of the county including Uttoxeter and Leek.

DID YOU KNOW?
Leek's first police station was built in 1848 and still stands today. It was not in Sheepmarket or the Market Place as people believe but between Mill Street and West Street and it later became part of West Street Club.

In 1842, a police constable's pay was 14s a week, a reasonable although not high salary for the time, especially given that he was expected to work nine hours a day, seven days a week and all without meal breaks. There were no rest days and leave of up to fourteen days per year was only granted to 'well conducted' men and only by the specific permission of the chief constable. By the end of the following year it was clear that few of the new

recruits were suited to this military-style life and out of the 200 men recruited more than one third had been dismissed, discharged or had resigned. The ones who remained in service and were successful in the force were probably ex-soldiers like Sergeant Herbert Moreton, who had joined the Bilston force straight from the army and then transferred to Leek. He had been an NCO in the Staffordshire Regiment and so would have been accustomed to strict discipline and long hours and probably appreciated the lower risk to life and limb involved in policing rather than soldiering.

At the time when the force was established, policemen wore tailcoats cut square at the waist in conjunction with a top-hat, but in the 1860s this was altered to a frock coat and kepi. At around this time officers began to wear helmets at night and in severe weather conditions. Some forces soon adopted these full-time. Communication between police constables and between them and the local 'police house' was problematic in the early days so adjacent beats would have conference points where constables would meet and exchange information. In towns whistles were carried and constables were expected to always remain within whistle range of one another.

In the *Staffordshire Advertiser* of 10 April 1847, five years after the establishment of the force, Revd John Sneyd, a wealthy land-owning magistrate from Cheddleton, was appealing to the court sessions to purchase land on which to build a permanent police station for Leek. Chief Constable Hatton stated that, given the 'limited number of the Police Force kept in Leek', it would be desirable to site such a police station in the town centre. The price of land proved to be an issue and it seems that the location selected was probably not one that Hatton would have recommended. Regardless of that, in 1848 the County was responsible for building Leek's first police station and it is here where fact clashes with folklore.

Many people believe that the first police station was located in Sheepmarket or the Market Place. The truth is that while there used to be a 'lock up' in the Market Place near the end of Sheepmarket, this was in no sense a police station and was demolished when the old town hall was built in 1806. The town hall itself had two 'miserable stone dungeons' underneath it and in 1849 was described as the 'Market Hall and Lock-up'. Miscreants guilty of such crimes as fighting in the Market Place would be put into these cells, referred to as 'The Hole', to cool off.

Leek police kepi. (Courtesy of Nicholson Institute Collection)

Leek's first police station was actually located near the junction of West Street and Mill Street and served in this role for nearly half a century between 1848 and 1891. What will perhaps surprise people even more is the fact that this old police station still seems to be standing and that virtually every Leek resident will recognise it. This police house does not seem to be clearly signposted in literature and there appear to have been no photographs taken of the front of it when it was in use. Local historian George Lovenbury stated in a *Post & Times* article that the old police station was in what used to be West Street Working Men's Club, a statement that was correct to a point but possibly slightly misleading; Overton Buildings, which formed the right hand end of West Street Club, was not built until 1907, fifteen years after the police station had closed so it wasn't the whole of West Street Club that used to be the police station. There are postcard photographs dating from between 1896 and 1907, showing what was in place before Overton Buildings was built and it seems that one or both of the buildings shown housed the police station. Sale documents from *c.* 1907 might eventually reveal the precise size and position of the police station.

Although today we might think of this location as being virtually in the town centre, at that time only a short distance down 'Barn Gates', as West Street was then called, was the Britannia Inn and beyond that the street became a track running through fields towards Westwood Hall. Prior to 1881, the junction between Mill Street and 'Barn Gates' was via

Left: View of the old police station, pre-Overton Buildings of 1907.

Right: Leek's first police station and courthouse (1848) in West Street.

A key to a cell, probably from West Street Police Station.

a 'narrow inconvenient passage', which was altered by buying or acquiring land from various bodies, including Stephen Goodwin's mill (where West Street Co-op is now) and by reducing the size of the 'Police Station yard'. This allowed West Street to be widened and also improved its junction with Mill Street.

A widely held belief is that the tiny building in Mill Street next to the former club, and recently rebuilt, held the cells to the original police station, something else that seems to lack documentary evidence but could perfectly well be true and again may be confirmed by sale documents. What is known is that West Street police station had three cells. A descendant of Herbert Moreton, one of Leek's police sergeants, has in her possession an ornate key stamped on one side with 'Leek' and on the other side with 'Cell'. This key would have been in Sgt Moreton's possession while he was in the force between the early 1890s and October 1909. This coincides with the time that the police station transferred from West Street/Mill Street to Leonard Street and so it seems likely that this key is from the original station. Another key has since come to light that definitely did unlock one or more of the cells in the later police station and that key is much larger.

DID YOU KNOW?
In 1842, a police constable was expected to work nine hours per day, seven days a week and without meal breaks or rest days. Fourteen days leave per year *could* be granted to 'well-conducted' men by the chief constable. For this, the pay was 14*s* per week.

Possibly the first superintendent in Leek was Capt. William Henry Lance, who lived on Compton in 1851 and was also the Inspector of Weights and Measures. By 1871 he had been replaced by Charles Williams, formerly a sergeant in Cheadle. He lived at No. 4 West Street with his family and four other policemen. A directory published the following year stated that Williams had one sergeant and five men under his command at West Street and that the 'petty sessions are held at the Police Station every alternate Wednesday'. The police station therefore contained accommodation for the superintendent and other men together with a court-room. Perhaps Williams was very good at discouraging criminal activity, or else was very lenient because on 25 January 1873 there was a report in a local paper stating that the police cells had been empty for three weeks, which was 'extraordinary' and had not happened for 'a great many years'. It seems that the police court tried minor cases such as that brought against a farmer for riding in a carriage of a superior class on the North Staffs Railway and against shopkeeper Ralph Redfern of Ipstones, charged with 'insulting a policeman'. However efficient or otherwise Williams' had been, in 1883 it was reported that several influential gentlemen had proposed public recognition of the long service of Mr Charles Williams, 'Late Superintendent of the Leek & District Police'. On his retirement, he had served Staffordshire Police for at least thirty years.

Because Leek was expanding and the population growing, by 1890 a new, larger police station was needed to house a larger force. Tenders were invited from architects to design a new purpose-built police station and William Sugden & Son were successful in their bid. The building was to be situated near the cattle market in Leonard Street and, as was normal with the Sugdens, the firm chose an unusual architectural style based on the Scottish Baronial style, with conical roofed turrets. This would be one of the last major projects on which father and son William and Larner Sugden co-operated; William died in 1892, soon after the police station opened.

In the 1891 census, Eliab Breton had been superintendent at the county police station, which was still located at No. 7 Mill Street. He was forty-three years old and had been born in Leicestershire. He was married with five children, all apparently living in the same house. Only his three-year-old son had been born in Leek, suggesting that he had moved there *c.* 1889. Also at No. 7 Mill Street were George Bates (thirty-seven), John Hall (twenty-five), William Beddowes (twenty-nine), Harry Parkin (twenty-five) and George Bolton (?) (nineteen), all police constables.

The new police station had to house a married sergeant and his family, an unmarried sergeant and twelve constables. The highest-ranking officer, the superintendent, was housed in a detached building higher up the street. The station had an administration block, offices, a charge room, six cells, and an exercise yard for prisoners. Also on the site were stables, a coach house and a parade yard, and thus was more of a barracks than the police stations we think of today. The cells were on the ground floor, close to the main entrance, the first being what Americans call a 'drunk tank', with just a mattress on the floor and a toilet. There were four further cells all lined with amber and white glazed bricks. Just off the cell passage was the exercise yard, which measured about 10 feet by 8 feet, with an iron grill overhead to prevent prisoners escaping; this was also where identity parades were later carried out. The cells were apparently considered spartan right

Herbert Moreton outside the married Sergeant's house, Leonard Street.

Inset: Police Sergeant Moreton's retirement gift, 31 October 1909.

until the station closed in 1987, modern cells being much more comfortable. According to Kelly's Directory of 1912, the cost to build the entire complex had been £7,000. Former policemen remember that, until it closed, above the reception desk was a fan-shaped display of nineteenth-century police swords, known as 'hangers' together with some chain-gang chains.

At the time that Sergeant Moreton was photographed outside the married Sergeant's house (above) the house would still have been quite new because Herbert retired from the force in 1909, when he was presented with a gold watch inscribed: 'Presented to Sergeant H. Moreton By the Officers and Constables of the Leek Division on his Retirement from the Force on 31st October 1909'. The married sergeant's house still stands although now in desperate need of work to preserve the door, windows and other original woodwork. Eliab Breton had moved from West Street to the Leonard Street police station as its superintendent and under him he had two sergeants and eight constables. On 20 November 1896, four years after Leonard Street opened, some property was offered

for sale by auction: Lot 1 comprised a five-storey dwelling house formerly 'The Old Police Station', situated at the junction of West Street and Mill Street now occupied as a club. This confirmed that after the police had moved out, the old police station was converted into a club and in 1907 Overton Buildings were added to it forming the structure known as West Street Club, now converted to apartments. Police officers were not always above suspicion themselves and, in 1897, a local paper reported that PC Beddowes had been called to deal with Joseph Earls, a silk dyer who was drunk and disorderly in Picton Street; an elderly female witness stated that Earls was not drunk but that she thought PC Beddowes was!

According to the official history of the Staffordshire Police, detectives were not introduced to the Staffordshire force until 1894. Ten constables were then selected for 'detective duties' on pay of 4*d* per day. Interestingly Herbert Moreton was described as a detective in Bilston on his 1887 marriage certificate. Perhaps he had done some limited 'plain clothes' work and felt that that entitled him to call himself a detective, which would look rather more impressive than police constable on his marriage certificate. Leek Police Station is no longer the base for any detectives. In 1901 Eliab Breton was still the superintendent of police at Leonard Street and living next door to him and his family were six police constables who were described as boarders. They were: George Oulton

Left: A Leonard Street police station cell, in use until 1987.

Right: As yet unidentified Leek Police Constable No. 90.

Leek officers attend an overturned lorry on Buxton Road.

(twenty-nine), Joseph Sykes (twenty-six), Robert Pitt (twenty-four) Herbert Bradley (twenty-five) John Bennett (twenty-three) and William H. Hodson (twenty-four). Perhaps one of these men was officer No. 90 of whom Herbert Moreton retained a photo after his retirement. None of the constables was from Leek, possibly a deliberate policy to stop any favouritism being shown by the officers, or undue pressure being applied to their families. Also present at the police station was Arthur Hall, a brickmaker from Ellaston aged twenty-nine, who was a prisoner. Eliab W. Breton had obviously done a good job in Leek because by 1911 he was the deputy chief constable of Stafford. Two of his sons were solicitors and so had following in their father's interest in maintaining the law. Breton lived in Eastgate House, which with nine rooms was clearly a comfortable dwelling.

By 1912 the size of the Leek force had once again increased: Samuel Hicklin was chief superintendent, with three sergeants and thirteen constables under him. The force now also had two police surgeons, Reuben Burnett and Edgar Brunt, operating from Moorland House.

Following the introduction of the 1930 Road Traffic Act, a motor transport and patrol group was formed to police Staffordshire's roads. Initially there were just three Austin Tourer cars based at Stafford for the whole county, but this was soon found to be inadequate and so new cars were purchased to operate from every divisional station. Road traffic accidents became an increasing part of policing duties and today it is rare to see a police officer anywhere other than in a motor vehicle.

DID YOU KNOW?

In 1944, six female police officers were enrolled into the Staffordshire force, their duties being to deal with problems involving women and children. In Leek, Marjorie Beardmore, née Sherratt, was appointed a WPC *c.* 1944. She described her duties as being to look out for 'fallen women', children and people at risk.

Leonard Street police station closed in 1987 and was replaced by the present building in Fountain Street. Given the large size of the present building and the relatively small number of officers based there today, the majority of the building must be underused and is reportedly largely utilised for storage. The cells are completely unused as everyone taken into custody goes to the Northern Area Custody Facility (NACF) at Etruria. It seems likely that Leek will soon be without a police station at all, current proposals seeming to be like other local forces; the police will move into the local council offices and the police station will be sold off for development.

Leonard Street police station in 2016.

Fountain Street police station in 2016.

7. Leek Through the Smoke

Ever since people took to living in dwellings constructed from flammable materials, fire has been an ever-present danger to individual buildings and even whole towns and cities. Leek suffered a large fire on 9 June 1297, in which the parish church was razed to the ground and, according to one chronicler, virtually the entire town was destroyed. The severity of the fire was due to wooden buildings with thatched roofs being located in narrow streets, allowing the fire to spread rapidly. In the thirteenth century most of the larger Staffordshire towns were destroyed by fire. On a much larger scale, the Great Fire of London (1666) destroyed no fewer than 13,000 houses, eighty-nine churches and devastated 80 per cent of the capital city. It burned for five days and it was only the deliberate blowing-up of buildings in its path, creating a 'fire break', that allowed it to be controlled. The loss of life was relatively small but the effects on the population were enormous and lasting; families were made homeless and livelihoods destroyed. So momentous was the fire that it brought about significant changes in the way that fire was thought about.

Firstly the idea of fire insurance was thought up and hand-in-glove with that was the establishment of fire brigades to put out fires in insured buildings. Any building that had been insured would be issued with a brightly painted metal fire mark attached to the front of the building. The fire marks designated that the building was insured and which 'fire office' (insurance company) had insured it. In towns and cities where a number of fire offices operated, the relevant fire brigade for a particular fire mark would be summoned to a fire. There were in excess of 150 companies who issued fire marks and,

Lead Salop fire office fire mark. (Courtesy of Nicholson Institute Collection)

when a company altered its logo, the number of variants increased still further. The Leek fire mark shown in the photograph bears the three leopards faces of the arms of Salop (Shropshire) and is one of two in the Nicholson Institute Museum collection, one bearing the word Salop and the other with a policy number below the leopard faces.

In Leek at the time of its great fire and on into the time of the Great Fire of London, the main defence against fire would have been leather water buckets passed hand-to-hand from the nearest abundant source of water. It has to be wondered what source of water would be used for a fire in Leek town centre? The buckets used were provided and maintained by the churchwardens of the parish church. Leek's first fire engine, a Newsham, was presented to the town by the First Earl of Macclesfield, between his purchase of the Manor of Leek in 1723 and his death in 1732. This was placed under the control of the Water Bailiff! Although state of the art in the 1730s, Richard Newsham's engine was a fairly crude wooden machine, pulled by hand to a fire, and worked by pairs of men raising and lowering wooden bars on either side of the machine alternately, drawing water into the pump through a hose and out again through another hose (at fairly low pressure) on to the fire – more effective though than a bucket-chain. The second engine in Leek's arsenal was another manual engine by Tilley of London supplied by the then Earl of Macclesfield in 1805 and named Lord of the Manor. This was also placed under the charge of the Water Bailiff. In around 1837, engines were called out from both Leek and Macclesfield to attend to a fire at Swythamley Hall. Perhaps unsurprisingly given the distances and the state of the roads, damage valued at £2–3,000 pounds was sustained. Another incident involving early manual engines occurred at Wreford's silk mill in Leek, which burnt down on account of the engines not being powerful enough to quench the fire. The mill was only partly insured and 120 people were forced out of work.

DID YOU KNOW?
The first fire engines in England were built by Richard Newsham of London. Leek was provided with one of these by the Earl of Macclesfield in around 1730. It was still in the possession of Leek Fire Brigade in 1894 and was going to be placed in the Moorland Museum on account of its 'valuable antiquity' – but where is it now?

In 1849, a report compiled by the Committee of the Freeholders of Leek summarised the state of readiness of the town regarding fires. An estimate was presented for the cost of a new 'improved patent carriage fire engine' complete with pipes etc. 'capable of throwing a strong jet of water to a height upwards of 100 feet'. There was a further estimate of the cost of four uniforms (despite the fact that the 'full complement of men to work this engine' would be eighteen) There was an estimate for the payment to the men to work the engine three times per year and for someone to keep it, and the older manual engines maintained. The crew would be paid for attendance at fires, in addition to the three drills per year. These payments were to be met by the owner of the property

attended, if not insured or by the insurance company concerned, if it was. The report stated that five fire offices had agreed to contribute towards the outlay. These were the Salop, the Nottinghamshire & Derby, the Manchester, the Atlas and the Norwich Offices. The latter almost certainly the 'Norwich Union Society for the Insurance of Houses, Stock and Merchandise from Fire', founded in 1797. These companies were clearly all providing fire insurance in Leek at this date. The Yorkshire, the Star, the Imperial & the Royal Exchange Offices declined to contribute on the grounds of the small amount of business that they carried out in the town. Given that the freeholders had money in the bank obtained from town land rents, the committee stated that the freeholders 'would do well' to authorise the purchase of the new fire engine. Added to the cost of the engine there was also an estimate of £50 to build a new 'engine house' on the land set apart for it at the end of the cattle market. This building, attached to a cottage, was erected by Mr J. Ferneyhough, who also had the adjacent Cattle Market Inn built. All three buildings still stand today and the engine-house can be seen in the in the background on the right of the old photo and also as it looks today. This was not in any sense a fire station, merely a place in which to garage the engine(s).

After the 1855 Improvement Act, Leek's Improvement Commissioners took over the responsibility for fire prevention and placed control of the engines into the hands of the town surveyor. They also took measures to ban thatch to reduce the likelihood and spread of fires. By 1858, Shand Mason of London had produced their first steam-powered fire engine and in the same year fire offices came together forming a committee to share knowledge about fire-fighting and to advise people about insurance.

In 1870 the commissioners set up a volunteer fire brigade operating alongside the existing paid brigade and bought a new engine for them to use. In 1873, the two separate brigades moved into Leek's first proper fire station, converted stables at the top of Stockwell Street belonging to the Cock Inn, (not the building that stands there today).

Left: Fire engine shed next to Cattle Market Inn.

Right: Fire engine shed, 2016.

The new engine was a Shand-Mason, which cost £177 12s 6d and was to be paid for over a period of twenty years. The volunteers were placed under the control of Capt. William Spooner Brough Esq., son of silk manufacturer Joshua Brough, while the paid brigade was under the command of sanitary inspector Robert Farrow. The two brigades were merged as a single volunteer brigade in 1873, consisting of Capt. Brough, J. Bennet, C. Chapman, Francis Sharpley, T. Hand, James Walthall, T. Howard, C. Kirkham, Robert Farrow, I. Heath, B. Wardle, Job Tatton, Micah Carding, W. Carding, J. Gibson, H. Carding, and J. Turner.

Brough remained in command of the voluntary brigade for twelve and a half years and clearly took his duties seriously as witnessed by the following report:

> The members of the Volunteer Fire Brigade had a couple of hours of capital drill under the direction of Captain Brough. The Firefly was driven 'four in hand' by Dr Gailey to Rudyard Lake where 180 yards of hose were connected up, reaching to the Hotel Rudyard, where a splendid force of water was played over it. The men showed themselves to be in very efficient condition.

So efficient were they in fact that they took the Firefly to Aston in Birmingham where they won prizes competing to connect up hoses and bring water to play on a 'fire' faster than their competitors. At some point during his involvement with the fire brigade, William S. Brough, an amateur artist, began 'signing' his paintings with a fire helmet motif in a similar way to 'Mouseman' Thompson who 'signed' his wooden creations with a carved mouse.

In 1883, Brough resigned his post and moved to London. In 1884, the brigade became paid again and were placed under the control of Micah Carding, a long-term volunteer. The photo above/below shows eighteen firemen, including Capt. Carding posing around the Shand Mason 'Firefly' outside Leek's first fire station.

The fire brigade with 'Firefly' outside the old fire station in Stockwell Street.

In 1885, the Leek improvement commissioner's fire brigade and bath's committee report contained the statement that there had only been one fire that year, in William Challinor's stables at Pickwood Hall and that the brigade had 'proved their efficiency' by attending with two engines and two pumps within twenty minutes of the alarm being sounded. It also described a fire brigade demonstration in the Market Place which included the use of a 'jumping sheet', into which members of the brigade jumped from a high window and were safely caught by their colleagues. One of the commissioners then tried this for himself, followed by a number of young boys. The demonstration also showed that hoses attached to hydrants in the street could bring a jet of water to bear on the tallest building (The Red Lion?) more quickly than the large manual fire engine.

In 1889, there were only two fires, both extinguished using these hydrants – their pressure having been improved after work on the Mount Pleasant reservoir. The following year (1890) the brigade only attended one fire in Mr Sleigh's attic in St Edward Street. This fire would have been very difficult to get to had it not been for the new telescopic fire escape, which was used for the very first time. This fire was put out using only the escape and the 'horse cart', which carried hoses to be connected to a hydrant. The engines were not required. It seems that working in the fire brigade was something of a family affair; plumber & decorator Micah Carding was captain and was followed in the role by his son Joseph Carding. One of Micah's grandsons (Joseph's son) later became second in command and Albert Carding was also a long-standing member of the fire service.

DID YOU KNOW?
In the early days of fire insurance, every insured building would have a brightly coloured metal fire mark attached to its frontage. This meant that if there was a fire the brigade from the correct fire office could be summoned.

When Micah Carding retired from the brigade he was presented with a large jug bearing the dedication: 'Presented to Captain M. Carding by the members of the Leek Fire Brigade March 10th 1885'. This is now on display in the new community fire station.

In 1893 there had only been two fires in the past year and the committee felt that the brigade had never been in a better state of efficiency as now. When a fire broke out at the Grapes Inn in St Edward Street, the brigade was on site within eight minutes. Demonstrations of new steam fire engines were provided by Shand Mason of London and the Vulcan Company and a decision needed to be taken whether the present appliances were sufficient for the neighbourhood. In 1894, the present brigade consisted of captain, lieutenant, secretary, engineer, sub-engineer and fifteen firemen, none of whom was resident in the station. The town was well supplied with hydrants and valves and a good pressure of water and equipment was available at any required location in very short time. Interestingly, the Newsham fire engine, in the brigade's possession for about

Brigade Captain Micah Carding's retirement present, 10 March 1885.

160 years, was described as being of valuable antiquity and was awaiting being deposited in the Moorland Museum. It has to be wondered what happened to it?

In a report detailing the 'Origins & Progress of the Public Works belonging to the town 1855–1894', the period during which the improvement commissioners had been in control, it was stated that although numerous fires had occurred during the period, all had been dealt with satisfactorily except 'Booth's' and 'Tattons'. Booth's was a tannery in Ball Haye Road that was gutted in 1887 and had to be completely rebuilt. At this event, Mr Booth had accused Capt. Carding of ignoring his advice while fighting the fire but Capt. Carding was exonerated. 'Tattons' was William Tatton's mill in Upper Hulme, destroyed by fire in 1891. The Urban District Council, who replaced the improvement commissioners in 1895, bought a new steam fire engine, which was named 'Queen of the Moorlands'. Perhaps as an expression of pride in its new engine, the brigade had an expensive etched copper book-press made which could be used to impress a design of the engine on its various report-books. The press is now in the Nicholson Institute Museum Collection and both the name Shand Mason and Leek can be read on the engine.

One of Leek Brigade's best-known exploits involved a fire on 11 February that year at the boathouse belonging to Stephen Chesters-Thompson of Horton Lodge. The engine was lowered down to the boathouse using ropes and the fire was successfully tackled but it proved impossible to winch the engine back up the slippery snow-covered bank to Reacliffe Road. The decision was therefore taken to haul the brand-new engine across the ice, estimated to be two feet thick. This was successfully achieved by firemen and skaters combined and the engine safely returned to Leek. The following weekend the brigade returned with the engine to be photographed on the ice. This was the same day that the Rifle Volunteers marched the full length of the reservoir and back on the ice (*see* 'Leek Down the Barrel').

J. T. Brealey designed a new fire station, opened in 1898 on the same site as the old one (*see* 1. Leek on the Drawing Board). The station, of red brick with sandstone lintels, was

Etched copper bookpress. (Courtesy of Nicholson Institute Collection)

built by Thomas Grace and included a tall structure (now bricked in) next to the archway in which the tall turntable ladder on its large wheels was kept. There was also a drying house where wet hoses were hung. This building, although somewhat altered, still stands and is now occupied by a pub called The Engine Room. In 1897–98, Leek's fire brigade numbered twenty men, equalling a brewery brigade, presumably in Burton-upon-Trent, and only exceeded in Staffordshire by West Bromwich. In 1905, the brigade's equipment consisted of a 'valuable steam fire engine', two manual engines, and a fire escape.

When motor vehicles became more numerous, draught horses became harder to obtain so using a horse-drawn engine was a disadvantage. Motorised appliances were ready to go

The Leek fire brigade on a frozen Rudyard Lake, 11 February 1895.

The old fire station in Stockwell Street after its closure. (Courtesy of Jon Cruttendon)

at a moment's notice, providing a driver was available, whereas horses had to be caught and harnessed, a procedure that could take longer than reaching the fire. In the 1920s, more than 50 per cent of the brigades in Staffordshire, including Leek, were still using horse-drawn 'steamers'. Leek had its first motor appliance in 1924, named 'Wilson' after the chairman of the Fire Brigade Committee but the steamer continued to support the motor engine until 1936. Of course, once motorised fire engines became commonplace, brigades were sent to fires further afield e.g. to the Potteries some 11 miles distant.

In 1937, Tom Harrison became one of Leek's first two full-time fire officers and on top of his salary he received a rent-free house, part of the fire station, for which coal, gas and electricity were all provided. This must undoubtedly have been one of the best jobs available in Leek at the time. The door to the 'Engineer's House' was where the disabled entrance to The Engine Room is now. Tom travelled to Rolls Royce in Crewe every day for six months to qualify as the brigade engineer and returned fully qualified and with two special Rolls-Royce toolboxes. Both the fire engines and the ambulance, which was based at the fire station, had Rolls engines so Tom was able to repair either – he also did 'foreigners' for wealthy businessmen who owned their own Rolls-Royces. Also based at Leek fire station, at least for part of the time, was a lorry containing a workshop and a composite vehicle that could be used to learn maintenance. This vehicle consisted of an engine, braking system, steering, gearbox/differentials etc. but no seats, or external bodywork. On the inside 'walls' of the lorry were exploded diagrams of the various systems.

In 1938 (until 1941) a new body, the Auxilliary Fire Service (AFS) was formed to assist fire brigades during the war. The AFS tended to be a sort of *Dad's Army* of fire fighters and also included women. Their main fire-fighting tool were trailer pumps and although it is not known whether there was an AFS in Leek. The fire brigade certainly obtained two Berresford-Stork trailer pumps at this time. In the 1940s, Leek brigade also had an engine mounted with a turntable ladder and this is shown in the entry next to the Nicholson Institute, which, at the time led to allotments; Les Turner is shown on the ladder.

A composite vehicle on which to practice fire engine maintenance.

In the nineteenth and twentieth centuries, textile mills were a major fire risk, being huge buildings filled with flammable textiles and cardboard packaging. It is perhaps surprising that more did not succumb to the flames. In 1964, Job White's in Compton was destroyed by fire and the following year Clemesha Bros & Birch in New Street was also destroyed, such fires being capable of throwing hundreds out of work overnight. The photo below shows two of Leek Brigade's appliances in the 1960s in today's Silk Street car park; the town hall is visible in the background.

Later in its existence, the Stockwell Street station contained above the arch the firemen's day room and kitchen into which a 12-inch black-and-white television was eventually added. This room also contained the trapdoor leading to the pole down to the engine bay. This was on the far left of the station but has now been demolished and replaced by a new building. Next to the day room was the 'rec' (recreation) room containing a table-tennis table and a dartboard. At the rear of the building were sleeping quarters, used by men on the night shift as the two watches operated twelve-hour shifts. On the ground floor to the right of the arch was the watch room where emergency calls were received and the red switch for the siren was located. The siren was located at the top of the tower and was used to summon part-time firemen to the station. There were also bells in the homes or places of work of retained fire fighters. They received a retention fee and had to attend a drill once per week.

DID YOU KNOW?
In the nineteenth and twentieth centuries, Leek's silk mills posed a serious fire risk and many of them were damaged or destroyed by fire. In one year in the 1960s, two mills in Leek were completely destroyed by fire, leaving a large number of people out of work.

Above: Two new Beresford-Stork light trailer pumps, behind Leek fire station.

Right: Leslie Turner on a turntable ladder at the Nicholson Institute.

Above: Two appliances, Silk Street car park in the 1960s, with the Town Hall in the background

Opposite Above: Demolition of part of the fire station.

Opposite Below: The 2015 Leek Community Fire Station on Springfield Road.

Opposite Inset: Leek fire brigade button. (Courtesy of Nicholson Intitute Collection)

The Stockwell Street fire station eventually closed and a new station in Springfield Road opened on 21 July 1971. The new site provided plenty of room for equipment as well as space for training the firefighters. The station was equipped with a Thorneycroft water tender with a 45-foot ladder, a Dennis pump escape with a 50-foot wheeled escape and a state of the art hydraulic platform, which could be raised to 65 feet. There were also two Land Rovers: an emergency tender to deal with road and rail accidents and a pump carrying 80 gallons of water – these could access places inaccessible to full-sized engines. In 1974, the Staffordshire fire brigade was formed with all brigades finally under one organisation.

During Christmas 2015/16, a new £3.4 million community fire station opened on the same site as the previous station, by then outdated and expensive to maintain. The new station was designed to allow appliances to respond more quickly and effectively to emergencies. It also serves as a 'community hub' containing rooms that can be used free of charge by local community groups and houses Moorlands Radio.

8. Leek on the Way to Hospital

The first known ambulances were those used by the Saxons in the tenth century, around the same time that the Saxon cross standing in Leek parish churchyard was being carved. These early ambulances were used for patients suffering from conditions like leprosy or 'madness' and consisted of a hammock mounted on a cart. A century later, the Norman invaders used litters, similar to stretchers but suspended between two horses. In the mid-1860s, ambulance carts were introduced to battlefields in the American Civil War and by 1867 the City of London's Metropolitan Asylums Board employed six horse-drawn ambulances to transport smallpox patients from their homes to hospital. These ambulances were disguised to look like private carriages, but had large rear doors and rollers on the floor to allow patients on specially made beds to be slid in surreptitiously. An attendant would travel with the patient and the inside of the ambulance was designed to be easily decontaminated to prevent the spread of infection. Emergency horse-drawn ambulances developed from these and led ultimately to motorised ambulances in the early twentieth century.

Leek's first hospital was the Leek (Alsop) Memorial Hospital at the bottom of Stockwell Street, designed by William Sugden & Son and opened in 1870. It was a gift to the town by Adelina Alsop in memory of her late husband James, a silk manufacturer. Four years after

Infectious Diseases Hospital, Ashbourne Road, photograph taken by P. A. Rayner.

the 'Cottage Hospital', as it is known locally, opened a second hospital for the treatment of infectious diseases was built opposite the Union Workhouse on Ashbourne Road. This was a temporary structure but was replaced by permanent buildings six years later in 1880. This so-called 'Isolation Hospital' was probably built here because of its distance from the centres of population in the town and possibly also because of a possible link between the desperately poor people consigned to the workhouse and the prevalence of infectious diseases. The infectious diseases hospital was opened on the instructions of the improvement commissioners, the body who since the Improvement Act of 1855 had been responsible for administering improvements to the town in such fields as sanitation, health, street-cleansing, gas-lighting etc. As was the case in most committees and governing bodies in Leek these men (and men they were) were mostly silk manufacturers, lawyers and doctors. An early photograph of the infectious diseases hospital was taken by P. A. Rayner from the upstairs of the workhouse building and on it can be seen the medical superintendents house in the centre and the two separate wings, probably one male and one female.

> **DID YOU KNOW?**
> The first ambulances in England were constructed by the Saxons in the tenth century. These ambulances consisted of a cart fitted with a hammock in which patients suffering from conditions like leprosy and 'madness' could be carried.

Also visible is what may have been the hospital's very first ambulance, standing on the gravel drive and with no horses harnessed. It makes sense that the ambulance (and its horses) would be kept on site and sent out as briefly as possible to bring back infected patients. The type of diseases that were feared were scarlet fever, typhus, typhoid and influenza. Perhaps surprisingly, despite having its own mortuary situated beyond the left-hand wing, mortality at the hospital was quite low. An example of statistics at the 'fever' hospital as it was also known comes from 1891 when there were eighteen patients, who had an average stay of forty-seven days and not one of whom died. Back at the memorial hospital, ambulances were directly responsible for the demolition of a piece of Sugden architecture, as an arched gateway had been built in front of the hospital in 1894, but had to be removed later to allow ambulances to drive up to the door. This archway is visible on at least two post-1909 photos but is almost entirely obscured by trees. A further large extension to the hospital was opened in 1909, again to the design of the Sugdens, even though (William) Larner Sugden had by that time been dead for eight years and his father William for seventeen.

By 1921, Leek had a motor ambulance for accident and non-emergency cases but still used a horse-drawn vehicle for infectious cases. In 1924, the Hospital Convalescent Committee presented a new motor ambulance to the town and this improved, faster vehicle was adopted for emergency and non-infectious cases while the existing motor

Red Austin infectious diseases ambulance.

White Rolls-Royce ambulance.

ambulance was used to transport infectious cases. The ambulances were distinguished from one another by their colours, Mr Geoff Fisher recalls that when he was taken to the infectious diseases hospital with scarlet fever in about 1946 he travelled in a red ambulance whereas the accident and emergency vehicle was white. Former driver Ivan Heath also remembers that the ambulance, which carried infectious and 'mental' patients, who were frequently transported to St Edward's Hospital in Cheddleton, was red.

In around 1937, Leek's emergency ambulance was based at the fire station in Stockwell Street. According to Keith Harrison who lived there, it was kept in a concrete building on the right just through the archway in today's Silk Street car park. This ambulance

Haregate Road Ambulance Station.

Event at the rear of Haregate Road Ambulance Station.

Ivan Heath receiving a medal for twenty-five years of safe driving.

Goods train derailment at Leekbrook attended by Ivan Heath.

garage also doubled as an air-raid shelter owing to its extremely sturdy construction. Leslie R. Turner, one of the first two full-time fire officers in Leek, was responsible for driving either the ambulance or a fire appliance – difficult one would imagine if a fire involved casualties needing to be transported to hospital. By 1956 Leek's had two ambulances, which were kept in the town yard in Station Street, one a Rolls-Royce and one a Daimler. They were maintained by the county council but the crews were paid by Leek Council. Ivan Heath who applied for and obtained a position as an ambulance driver at Leek remembers that following his interview, he had to meet the station chief at the town yard and take a driving test, which involved him driving an ambulance both in traffic and also at high speed to show that he would be capable of performing his duties. He passed the test but by the time he commenced work as a driver (1957), the new purpose-built ambulance station had been opened on Haregate Road, where he worked for thirty-three years. Passing the test was clearly not a fluke because Ivan went on to receive a medal presented by Mrs Gardener, chairwoman of Leek Council, for a quarter of a century of safe driving. Ivan recalls clearly that when he started, the ambulances he drove were not white but blue and that they only changed to white when the service amalgamated with Stoke-on-Trent. A coloured pencil drawing in the possession of another former ambulance driver Tony Banks shows one of these blue ambulances. The value of employing local drivers was demonstrated when a message was received from the controllers to 'scramble' all the ambulances to a train crash in Leekbrook. Ivan Heath, who had come to the ambulance service from the railways, was able to reassure the controller that only goods trains used the lines and so panic was averted. In the event there was one casualty – the guard, who had fractured his ankle when he leapt from the derailed guards van.

The ambulance station on Haregate Road had about seven ambulance bays initially but another one was added later, separated from the others by an internal wall. The shift pattern meant that ambulance crew members were on site twenty-four hours a day but, unlike firemen and doctors, those on night shift were supposed to stay awake all night and no sleeping accommodation was provided; the no sleeping rule may not always have been followed.

DID YOU KNOW?
In the mid-1950s, Leek's ambulances were not white but blue. Earlier still there had been a red ambulance, which carried patients suffering from infectious diseases or psychiatric conditions.

As time passed, and infectious diseases began to be less dangerous, keeping an ambulance specifically for carrying such cases proved uneconomical and so any ambulance was used. When a patient suffering from a serious infectious disease such as polio or diphtheria had been carried the ambulance was fumigated and taken off the road for twenty-four hours. Fumigation involved placing a tablet on top of an electrical heater

inside the ambulance. The tablet melted, producing highly noxious fumes. This was referred to as 'bombing' the ambulance, but none of the former drivers spoken to know what the tablets contained. Ambulances were already equipped with radios in 1957 when Ivan Heath began working as a driver; having radio communication must have greatly eased the operation of ambulances although it has to be wondered how good radio reception was in more rural areas.

An unwelcome substance at Haregate Road ambulance station was water, in that the boiler house, located underneath the station, was constantly subjected to flooding and the staff would have to use a permanently installed hand-pump to pump the water out again. The staff used to put the flooding down to seepage from the 'River Novi'. There may actually have been some truth to the water coming from an underground stream because there are known to be several in the area. When a gas, rather than coke, boiler was obtained, the manual pump was replaced by an electrical one complete with a mechanism that caused it to switch on automatically as soon as the water in the boiler house reached a certain depth.

Driving an ambulance in Leek & District has always presented a number of particular difficulties connected with both the rural nature of the area, the topography and the weather. A Land Rover, converted into an ambulance at the Silverdale Road ambulance station in Newcastle had been used in Leek for a long time during wintry periods. This took one patient on a stretcher accompanied by an attendant in the back. When this vehicle was reaching the end of its useful life and a replacement was requested, the Chief Officer at Stafford HQ decided that the cost was prohibitive and that in any case it was not needed most of the time. In order to prove this, he travelled northwards in the next snowy period to act as attendant to the driver of an ordinary Leek ambulance. It seems somewhat predictable but on that day the ambulance received a call-out to Morridge, a high ridge overlooking the town, and while there the ambulance became completely snowed in, requiring an overnight stay for the two men at The Mermaid Inn. Once the embarrassed chief and his driver had been recovered the following day by two Land Rovers, the ambulance and one belonging to the police, it was not long before Leek took delivery of a brand-new 4WD Range Rover vehicle, the only one of its kind in the county. Another ex-driver was involved in a similar incident on Morridge.

Coincidentally on the day that the above was written, the front-page headline of the *Leek Post & Times* newspaper read 'New Ambulance Service for Town'. This concerned the fact that the single Rapid Response Vehicle (RRV) based at the Leek Moorlands Hospital on Ashbourne Road had been removed and replaced by a '4x4' ambulance, one of the first such vehicles to be based in Staffordshire!

In 2009, the West Midlands Ambulance Service had submitted a planning application to Staffordshire Moorlands District Council to base an RRV at Leek Moorlands Hospital, replacing the single Leek ambulance at that time based at a Buxton Road nursing home. The new RRV unit would provide better access to major roads in and out of Leek and it would be the first time that the town had a proper ambulance base since the Haregate Road station closed in 1996. The RRV would attend accidents and emergencies and give assistance, after which another ambulance would arrive and transport the patient to hospital if necessary; this left the RRV free to attend other incidents. The September 2016 system requires the new vehicle both to assist at the scene and also to transfer

patients to hospital, usually the Royal Stoke University Hospital. This seems to leave Leek without an ambulance at all while the ambulance makes its way through traffic to Stoke-on-Trent and back, which may 90 minutes or more. It seemed debatable whether this service is better, or just cheaper. The latest headline reveals that since the new system was introduced a collapsed man was left lying in Derby Street for an hour before being taken to hospital in a passer-by's car. At least for really serious emergencies there is always the air ambulance.

> ### DID YOU KNOW?
> The chief ambulance officer from Stafford declined to fund a Land Rover ambulance for Leek when the existing one was at the end of its useful life. In the next snowy period, he visited Leek to prove that it was not necessary but spent that night stranded at the Mermaid Inn on Morridge having become completely snowed-in. He was rescued by a Land Rover.

The topography of the area, and in particular the Roaches, causes its own problems for the ambulance service. The Roaches or Roches (from the French *roches* meaning 'rocks') is a popular area between Leek and Buxton for walkers and climbers and unfortunately is also a place where accidents frequently occur. Ambulance crews from Leek would be required to make their way to the foot of the climbing pitches (if they were lucky) or possibly half way up a climb in order to rescue someone who had fallen and possibly broken one or more limbs. The patient would then have to be secured to a stretcher before being lowered to the ground. Two police officers would also usually attend this type of incident and were much appreciated by the ambulance crew because they could then help to carry the stretcher to the ambulance with someone on each corner. Securing the patient to the stretcher in these circumstances was not something for which training was given and instead had to be passed down from person to person. These days of course the air ambulance can be deployed and it is frequently seen overflying the town on its way to the Roaches. The photograph on the next page shows the West Midlands air ambulance taking off from the West End recreation ground, an event generating a great deal of local interest.

Leek ambulance drivers could also be faced with interesting incidents relating to animals, for example when Bert Richards went to Hen Cloud on a call-out and arrived at Stoke-on-Trent later with a hole in his ambulance looking as though it had been made by a high calibre bullet. When he told his Stoke colleagues that he had been charged by a 'huge beast', they didn't believe it but it transpired that his ambulance had been gored by one of Courtney Brocklehurst's yaks, an animal notorious for picking fights with motor vehicles. Driver Ivan Heath faced a similar problem when carrying a female patient along the gated road at the back of Roach End. This journey involved opening and closing eight or nine stock gates positioned across the road and at some point on the journey Ivan

Bond air ambulance taking off from West End 'Rec' (2010).

found himself on one side of a gate and the ambulance, the patient and a large irate bull on the other. He waited for a considerable period of time before the bull lost interest and wandered off. The ambulance controllers wanted to know what had taken him so long to do what seemed to be a relatively short journey. He told them that the patient had offered him her crutch but that he didn't think that his contract of employment included bull-fighting. Ivan Heath's shift included the first female ambulance driver in Leek, Sue Godwin, who started work in 1979.

9. Leek Down the Barrel

Approximately 38 million people died in the First World War and the following influenza pandemic so it is hardly surprising that so much is currently being made of that horrific conflict a century after it took place. Quite a lot too has been written about the 'Old Leek Battery', who set off for the war in August 1914, but not so much has been published about the Leek Rifle Volunteers who immediately preceded the battery, and fifty-three of whom transferred into it in 1908.

Despite what might be assumed, England did not have a regular army until after the English Civil War (1642–51). This last conflict to take place on English soil was fought between Charles I on one side and Cromwell on the other. The opposing armies consisted of groups of fighting men loyal to noblemen who for a variety of reasons had decided to side with either the king or Parliament. The normal role of these private militias was to keep order in case of any kind of civil unrest, and their officers were gentleman who paid personally for the uniforms and equipment of the men under them, as well as supervising their training. Gentlemen, landowners or factory owners could call upon their militias if their lands or possessions came under a threat of any kind and examples of these threats were Bonnie Price Charlie's rebellion of 1745, the Luddites of the early nineteenth century and the Chartists, also in the nineteenth century. On his succession to the throne, Charles II wished to make sure that his power in the country was absolute and that he could not befall the same fate as his father, so a paid national army was established. This did not mean that there were no longer other fighting forces, loyal to individuals and yeomanry forces continued to exist but never again did such militias band together to oppose the Crown. In Leek there was still a yeomanry unit in existence in 1866.

Britain's relationship with France had always been difficult and during the 1850s, relations with Emperor Napoleon III see-sawed between entente cordiale and the threat of imminent war. Because of this, defences against an invasion fleet were strengthened and in late 1859 General Peel authorised the establishment of a volunteer force consisting of both rifle and artillery units. Almost immediately in Leek, efforts were begun to raise a corps of Rifle Volunteers and in February 1860 a sub-division of thirty men was raised to serve as the 28th Company of Rifle Volunteers. On 26 April 1860, the corps, now numbering sixty men, marched in uniform to be sworn in at West Street. It is not clear whether this signing took place at West Street Wesleyan Chapel, where the county court was held, or in the courthouse at the police station. In Miller's *Old Leeke*, there is a report of a framed and glazed parchment document relating to this event hanging in the orderly room' (although it is not specified where this orderly room was). The document was headed 'We, the undersigned, agree to become members of 'The Leek Volunteer Rifle Corps,' subject to the rules and regulations made by government for the formation and maintenance of rifle corps. Below this were sixty-three names, although three had been erased leaving a total of sixty. A further eight who joined later were added beneath the list.

> **DID YOU KNOW?**
> In February 1895, the Leek Rifle Volunteers marched the full length of Rudyard Reservoir and back behind their band – fifty-four men in all – on ice that had been in place for three months and was estimated at 2 feet thick.

The occupational make-up of the first sixty volunteers included three gentlemen, five silk manufacturers, (including William Tatton, head of the company of the same name), two solicitors, two articled clerks, fifteen warehousemen, two innkeepers and small numbers of other trades and professions. It would be interesting to see how many of them had been in uniform before and calculate how the proportions of occupations in the volunteers matched Leek's male population as a whole. It is probably unnecessary to point out that the officers were all influential and wealthy men: Capt. William Beaumont Badnall was a solicitor; Lt John Russell Jr was a silk manufacturer, as was Ensign Charles Henry Halcombe Snr. Drill Instructor William A. Eaton 'late 3rd light dragoons' was clearly a military man who knew what he was doing but was not in the same class as the officers and was a baker by profession. The corps' first drill was held at Mr James Alsop's shade (mill). William Eaton, presumably Sergeant Eaton, clearly did not remain in post for long because in 1865 a funeral with full military honours took place for Drill Instructor Sergeant James Mills of the 28th Staffordshire Rifle Volunteers; interestingly several members of the Leek Yeomanry Cavalry attended the funeral.

The corps' first report, published in August 1860, revealed that there were currently fifty-six effective men in the Rifle Volunteers all of whom had agreed to pay one guinea per year to cover annual expenses. This would have been a large sum for men in low-paid occupations and so it may have rather restricted who could be a member. There was a list of donations made by men of means who were connected with the corps beginning with the Earl of Maclesfield and solicitor John Cruso. The accounts included a payment for gas pipe and burners for the drill room (Alsop's shade?) and a donation to pay for blinds to be put up there. The 28th Staffordshire Rifle Volunteer Corps joined the First Admin Batallion in May 1861 and became 'I' Company in 1880. In 1871, their commanding officer was G. S. Carruthers.

Although the threat of war with France never materialised, over the next forty-seven years the number of officers and men in the Rifle Volunteers doubled. In 1868–72, there were 100 officers and men. In 1892, 110 and, in 1907, shortly before they were disbanded, there were 120. The popularity of joining the volunteers was partly because of the opportunities it gave the men to do things that would otherwise not have been available to them: rifle shooting, camps, mock battles etc. Marching around the town in uniform, carrying a rifle may also have considerably improved the men's eligibility with the opposite sex. The corps also looked after the men's pastoral needs and in 1880 Revd Evans Belcher was their chaplain, as well as being the curate in charge of Compton School Church.

An article in a local newspaper from the late 1860s stated that 'it seems very strange that while the Leek Volunteers are stronger than at any period, the local auxiliary

Officer's green Home Service helmet.

cavalry force should be in 'exactly reverse condition'. Raised in the eighteenth century, the yeomanry had been healthy until 1826 but between then and 1842 declined sharply, eventually ceasing to exist. In 1842, it was relaunched and its numbers peaked at seventy but between then and 1866 the numbers again declined and in 1866 only thirty-one members attended an event in Lichfield.

Initially, Rifle Volunteers wore grey uniforms and their headwear was the shako, a sort of tall peaked cap, the rear of which sloped quite steeply towards the front. They looked not unlike confederate soldiers of the American Civil War. The badge or 'shako plate' bore the bugle horn, which was common to all the Rifle Volunteer corps and in Staffordshire this was combined with the Stafford knot. The insignia of volunteer units, including their buttons, were made of white metal or silver plate in the case of the officers whereas the regular army wore insignia either of brass or gold-plate. The shako was later replaced by a dark green Home Service helmet, the green of which was so dark that in certain lights it looked black. In 1878, the volunteers abandoned their 'rifle grey' uniform and began to wear the same scarlet tunics as the regular army.

Marksmanship was obviously an important skill in a Rifle Corps and Leek's volunteers did very well in competitions held at various locations including the National Rifle Association's grounds at Wimbledon (later transferred to Bisley). The Volunteers were able to hone their skills on their own 800-yard rifle range ('butts') situated by 1892 at Wall Grange, about a mile from the town centre. The photo below shows Sergeant Hall with some of his trophies after a competition at Bisley in 1902. He is shown wearing a glengarry. The volunteers may have marched regularly to Rudyard as an early P. A. Rayner photograph shows them posing on the Macclesfield Road all wearing glengarries.

Left: Sergeant Hall, Leek Volunteers, with marksmanship trophies (1902).

Below: Rifle Volunteers photographed by P. A. Rayner on Macclesfield Road.

Above: Alsop's 'shade' by P. A. Rayner; the Rifle Volunteers drilled on the top floor.

Below: The old armoury in Ford Street, now three houses.

A difficult question concerning the volunteers is precisely where their headquarters were. According to *Old Leeke*, the volunteer's first drill took place in Alsop's Shade and elsewhere it was stated that by 1894 the volunteers used the upper storey of a converted building in the Cattle Market. This description also fits Alsop's Mill, later the Coffee Tavern, demolished in the early 1960s to make way for the present Smithfield Centre. At the time that P. A. Rayner photographed this building, probably in the 1880s, it looked rather dilapidated but was probably in use by the Volunteers at the time. Kelly's Directory of Staffordshire (1868) stated that the headquarters of the volunteers was the town hall but this could not have been the large building in Market Street remembered by Leekensians today. Because that building was not yet built; it must therefore have referred to the much smaller building of 1806 near the end of Sheepmarket. That building would clearly not have been large enough to house even the initial volunteers crammed together like sardines. This mystery is probably explained by the 1860 volunteers' report, which includes an account of the payment of £6 2s 6d for alterations and fitting up of the room at the town hall for the armoury. It seems that rather than being the volunteers' headquarters, the town hall was where their rifles were housed. By 1872 the volunteers seem to have transferred their headquarters to Ford Street where there was a drill room, known as the armoury, to which a reading room and gymnasium were added in 1877. The reason for the move was that in 1872 the town hall was auctioned off and demolished. Directories of 1892–1904 continued to state that the volunteers' headquarters was in the cattle market. Perhaps the Manchester- or Birmingham-based compilers had just not been made aware of the volunteers' move to Ford Street.

DID YOU KNOW?
Leek's Rifle Volunteers were very proficient marksmen and won many competitions throughout the country including at the National Rifle Association grounds at Bisley. For practicing, they had their own 800-yard rifle range at Wallbridge.

The Rifle Volunteers were only part-time and although initially independent they became increasingly integrated with the regular army. Their uniform, apart from the insignias, became just like that of the regular army. The Cardwell Regulation of the Forces Act 1871 (referred to as the Localisation reforms) meant that regular army infantry brigades became associated with certain counties, and volunteer corps were then associated with their specific brigade. Staffordshire, being a large and populous county, was divided into two served by the North and South Staffordshire Regiments. The Childers Reforms of 1881 further refined this and the Prince of Wales North Staffs Regiment was formed. In 1883, the Leek Rifle Volunteers were formally designated as part of the 1st Volunteer Battalion, Prince of Wales North Staffordshire Regiment. This is why the helmet plate and the glengarry badge of the Leek Rifle Volunteers bore the Prince of Wales feathers and motto *'Ich dien'* (German for 'I serve'). The volunteers' uniform had

Right: Leek Rifle Volunteers Glengarry Badge (other ranks).

Below: Leek Rifle Volunteer Sergeants by P. A. Rayner, Colour Sergeant rear left.

Commanding Officer Captain Phillip Jukes Worthington 4 July 1886.

1883–1901 officer's silver-plated Home Service helmet plate.

been red with blue facings, but in 1886 this was altered to include the white facings of the North Staffs. Regiment. A uniforms 'facings' are where the lining of the uniform is visible on the outside e.g. at the cuffs and down the edge of the tunic. There used to be a great variety of facings colours but from 1881, as an economy measure, these colours were limited and all English and Welsh regiments were given facings that were white. A studio photograph of the volunteers' sergeants shows them in uniforms including Home Service helmets and with white facings. The commanding officer of the corps, Capt. Philip Jukes Worthington, was photographed at Sandeman & Hodgson's studio in 1886 and it can be seen that the facings of his uniform were also white. He is wearing his home service helmet with its silver helmet plate.

> **DID YOU KNOW?**
> In 1860, there were thirty men in the Leek Rifle Volunteer Corps but by 1908, when they were disbanded, there were no fewer than 120 officers and men. Fewer than half of these men transferred into the Territorial Force Battery in 1908.

Captain Worthington is shown carrying his sword, which would have had a bugle horn on the pierced basket hilt. The blades of these swords were generally etched but not all would have had spelling mistakes on them like the example shown belonging to an officer of the 'Rifel Volunteers'.

The winter of 1894/95 was extremely cold with temperatures as low as -12 degrees Celsius on 6 February 1895 and not exceeding freezing until 6 March. On the weekend of 16/17 February, the Rifle Volunteers did something still talked about 121 years later. Only a week after Leek fire brigade had been forced to haul its engine over the ice on Rudyard Reservoir (*see* 7. Leek Through The Smoke) and on the day the brigade returned to have their photograph taken, the Rifle Volunteers Corps under the command of Capt. Thomas J. Smith and Lt Fred Davenport of Woodcroft, complete with their band, a total of sixty-four men, marched from Leek to Rudyard. When they reached the reservoir they formed up in fours and marched the full length of the reservoir behind the band, who were playing 'The First Shot'. At the far end they turned around and marched back to the tune of 'E Dunno where 'e are'. During the 4 mile ice-march, only two men slipped over, the drummer and the sergeant instructor and a photograph was taken by 'Mr Johnson' of the group posing in front of a boathouse. The photo appeared in the *Leek Times*, accompanied by an article titled 'Our Volunteers at Rudyard.' It seems somewhat ironic that after this feat, two volunteers, Privates Henry Bennett and John Bode later drowned at Rudyard while fishing in 1907, although there has always been a suggestion that alcohol may have played a part in the incident. Henry 'Drummer' Bennett was a butcher aged twenty-six of Chorley Street and John Bode was a thirty-one-year-old carriage builder of Portland Street. In the men's funeral procession, which took place on 18 July, the corps is marching along Compton towards the cemetery with 'reversed arms', holding their rifles

Military funeral procession for Privates Bennett and Bode, July 1907.

Rifle Volunteers posing on frozen Rudyard Lake February 1895.

at 45 degrees with the barrel pointing downward and to the rear. The coffins were carried on gun carriages belonging to the Shelton Artillery Volunteers, formed at the same time as Leek's Rifle Volunteers.

The 1st Leek Company of the Volunteer Rifle Brigade ceased to exist at midnight on 31 March 1908, six years before the 'Great War' broke out. On 1 April, the Territorial Forces and Reserves Act came into force and the 3rd Battery of the Royal Field Artillery was born. Only fifty-three of the 120 officers and men of the Rifle Volunteers joined the new Leek Battery.

Etching detail on Rifle Volunteer officer's sword – note the spelling mistake.

About the Author

Neil Collingwood has just celebrated his sixtieth birthday and lives in Leek, Staffordshire, having returned to the place of his birth around ten years ago. He had already compiled two local history photograph books about Newcastle-under-Lyme in his spare time and having been made redundant from his job as a council officer, Neil set to work trying to make a living from local history and genealogy. He has now published a total of eleven local history volumes, together with writing *The Dragonflies of Staffordshire*, the first ever atlas of Staffordshire dragonflies. Neil enjoys nothing more than to research local history topics that no-one else seems to have bothered with and hopefully to uncover surprising new facts.

Acknowledgements

Bud Abbott, All Saints' Church, Paul Ashton, Jason and Tony Banks, 'Becalmed' Dennis Belfield, Bamboo, Bank House, Benks, Paul and Janet Breeze, Stef Callear, Peter Corden, Cycle Solutions, Jon Cruttendon, Den Engel, Stella Done, Fearns Marriott, Fresh Hair, Geoff and Jean Fisher, Sue Fox, The Gallery, Ashley Grange, Keith Harrison, Harrison's Greengrocers, Ivan and Joyce Heath, John Holland, the staff of Leek Library, Maria Killoran, Leek Town Council, Leek Working Men's Conservative Club, the NatWest Bank, Nixon Reeves, Steve and Liz Owen, Steve and Jan Panek, Tanis Pickford, Bruce Richardson, Rymans, Gail Sherratt, Silken Strand, Malcolm Sperring-Toy, John D. Spooner, Staffordshire Fire Brigade, Staffordshire Moorlands District Council, Adrian and Jackie Sumerling, Brett Trafford Photography, Cathryn Walton.

Sincerest apologies to anyone I have accidentally omitted from this august list.